The Littlest Darlings

By Kelly Horton

Copyright 2019 Kelly Horton

ALL RIGHTS RESERVED

This book belongs to

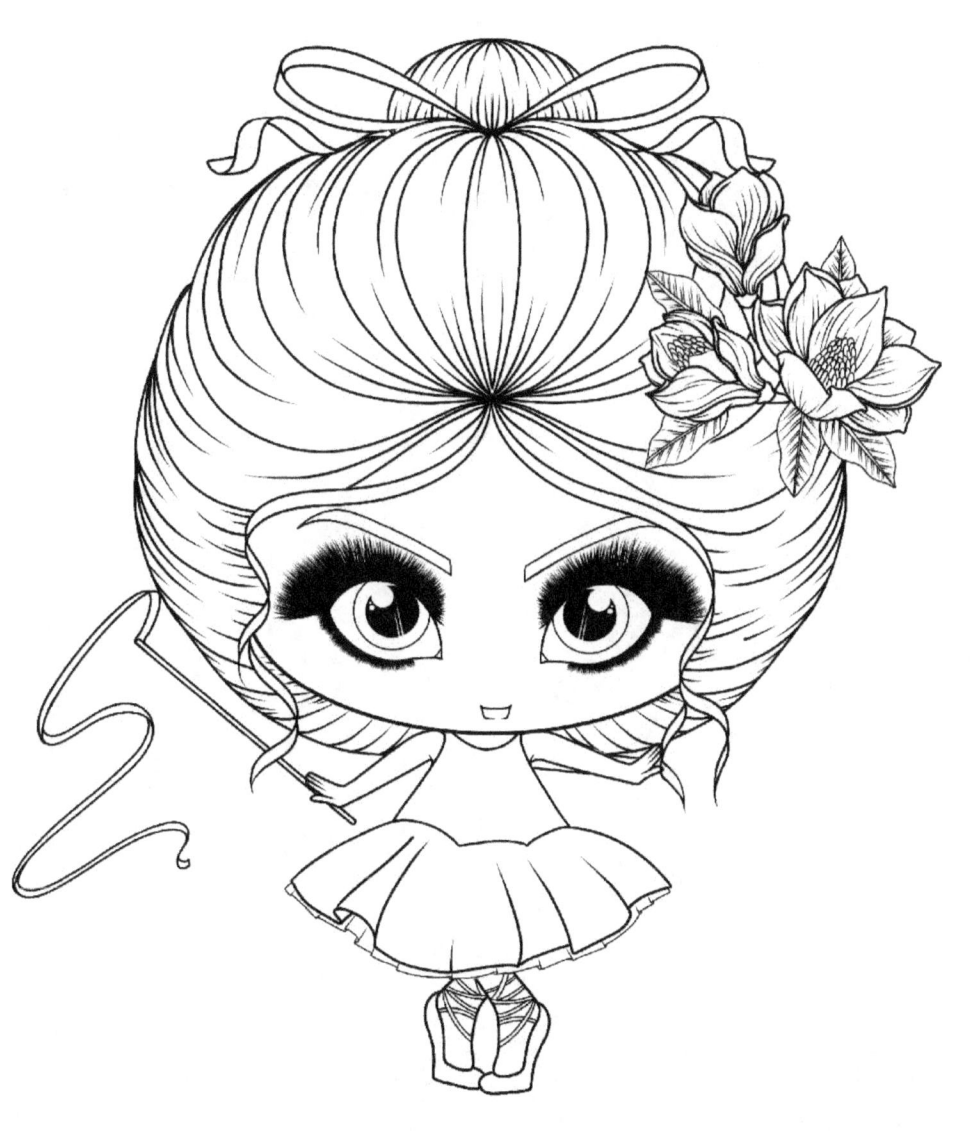

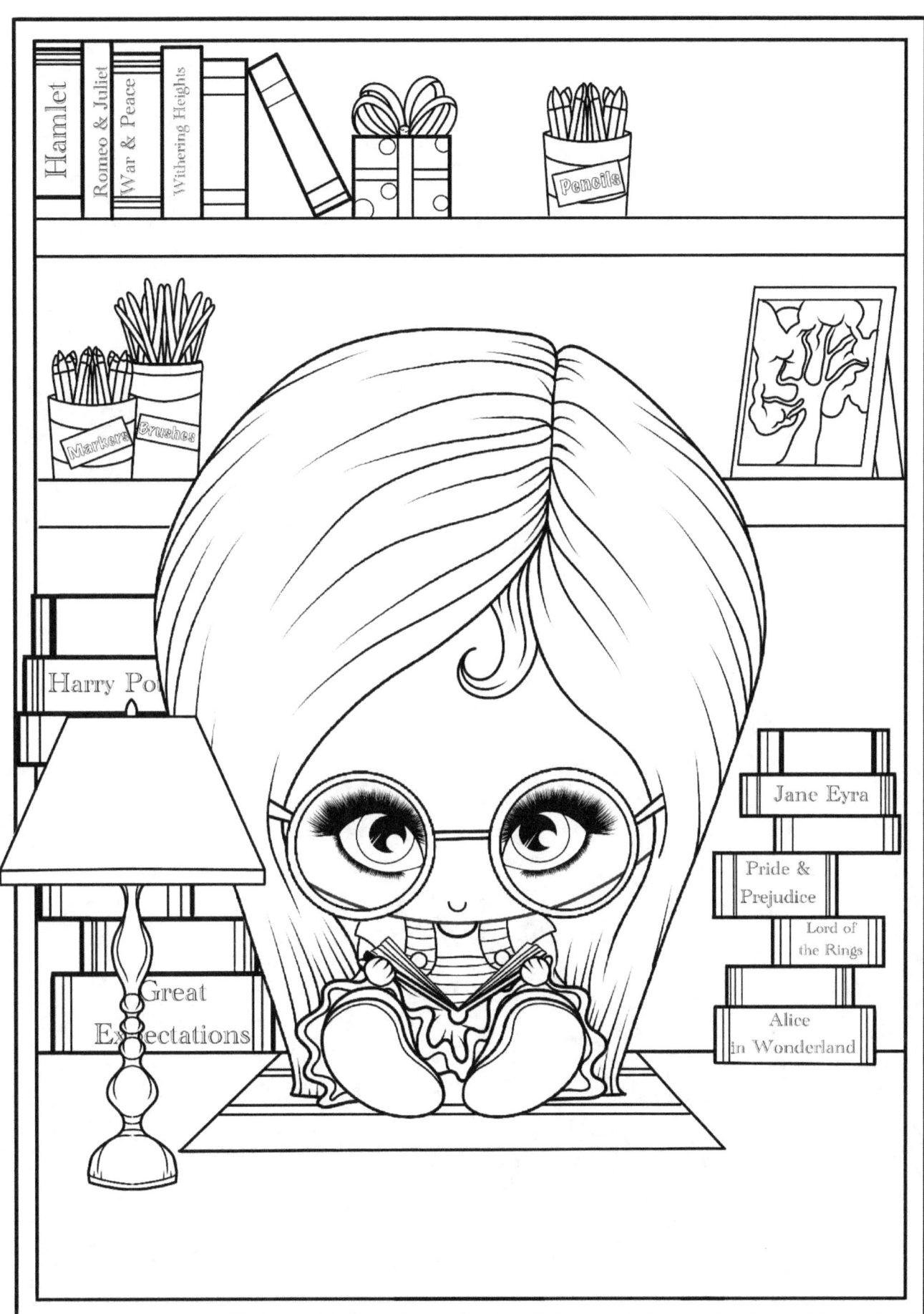

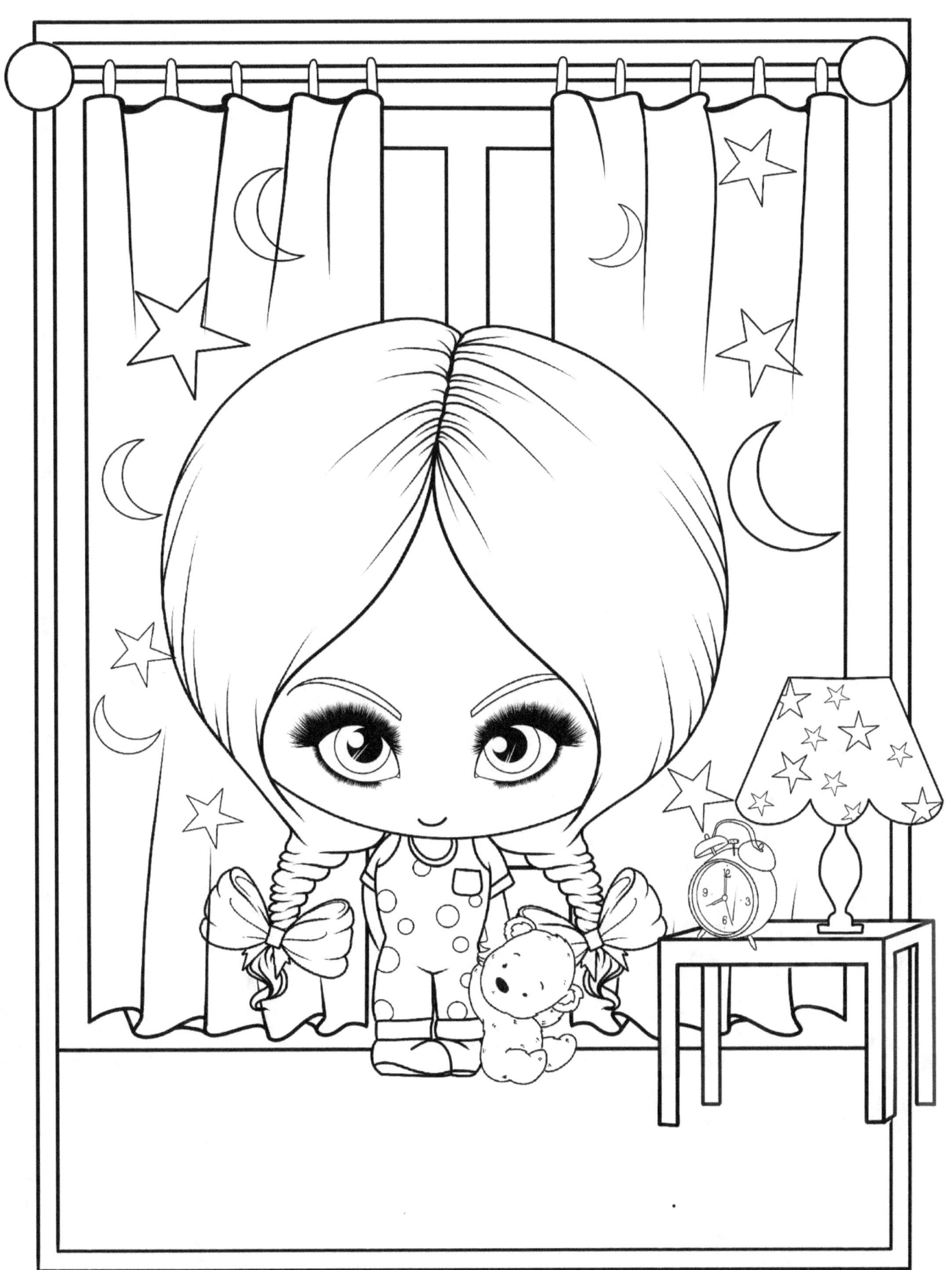

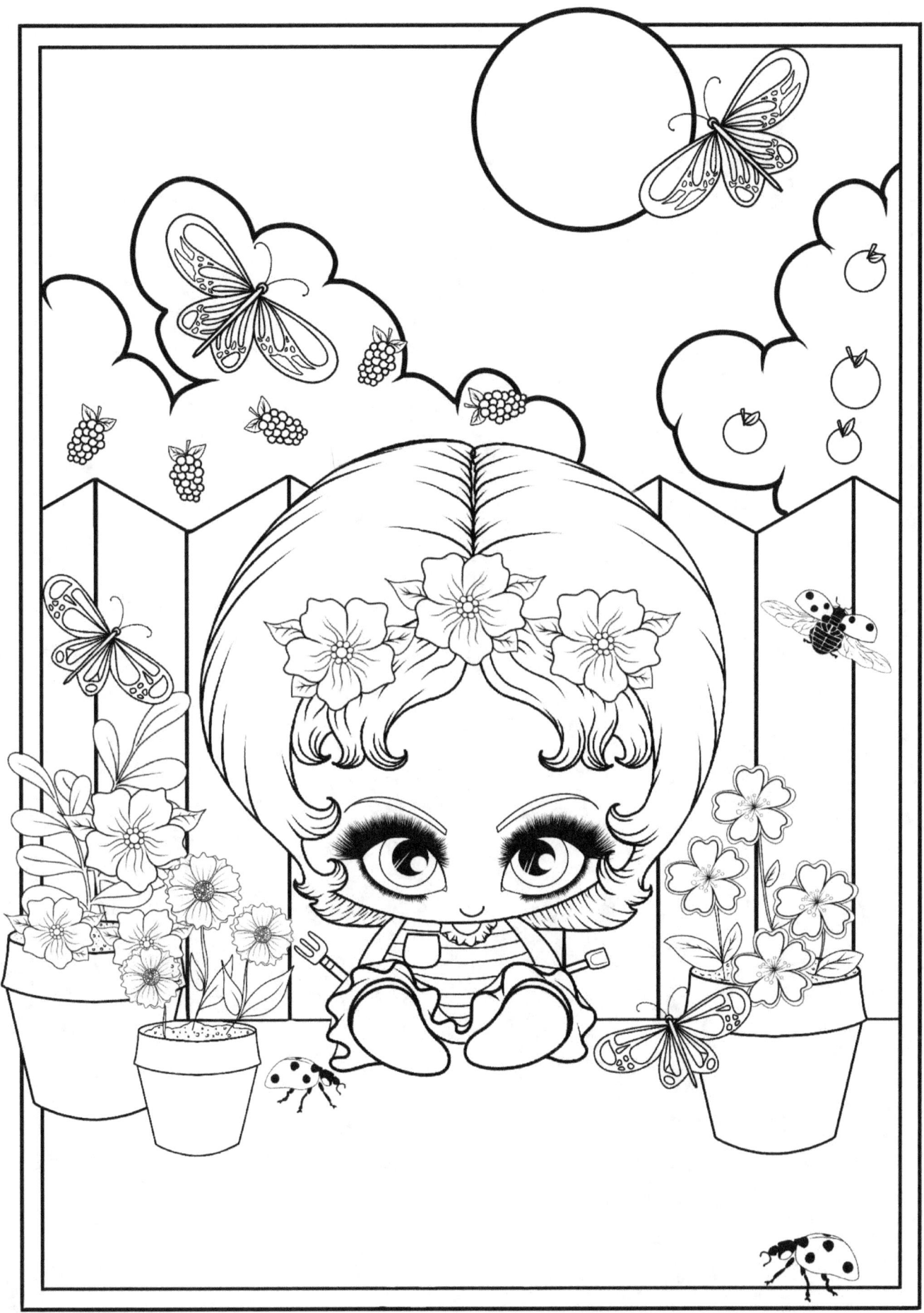

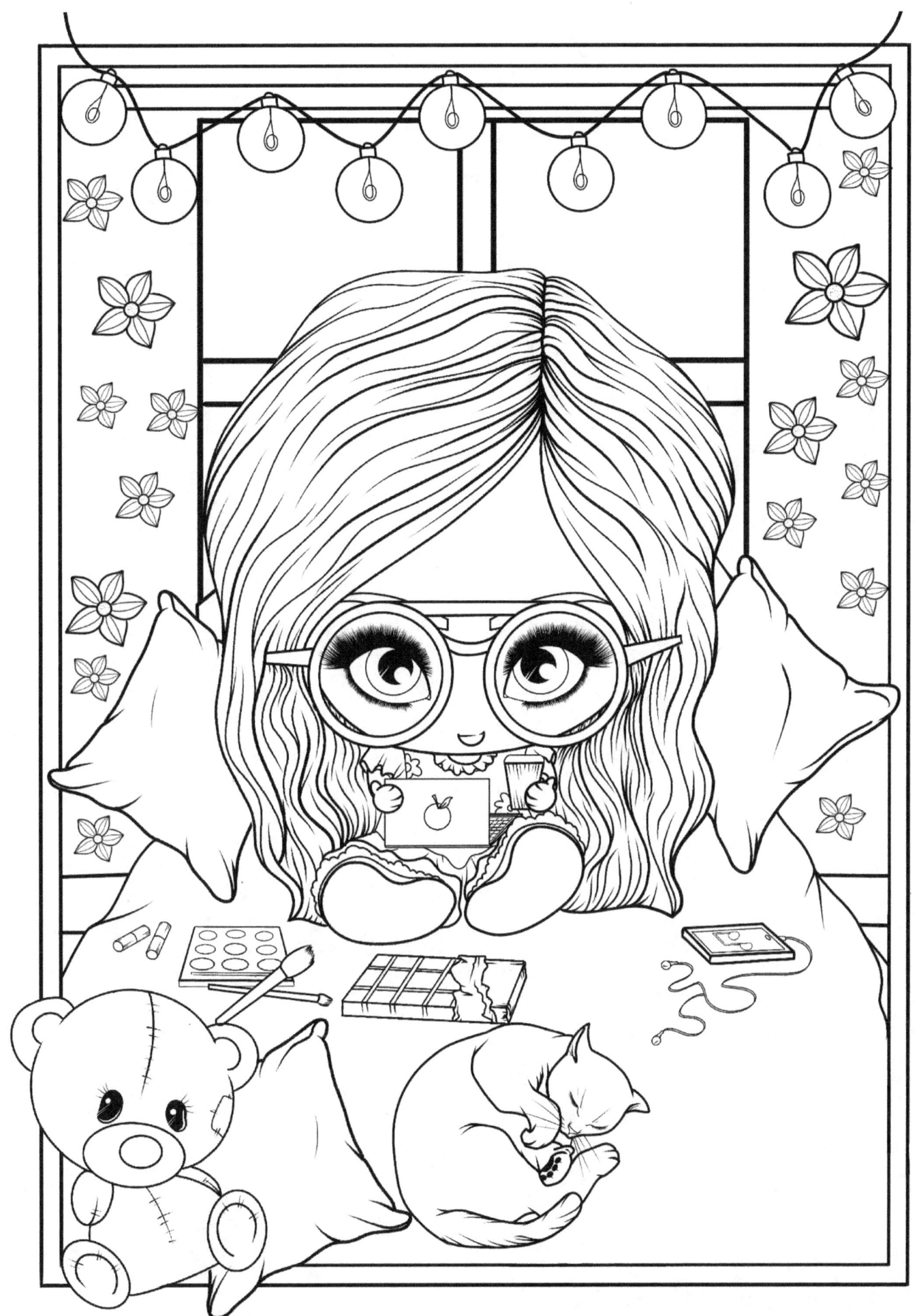

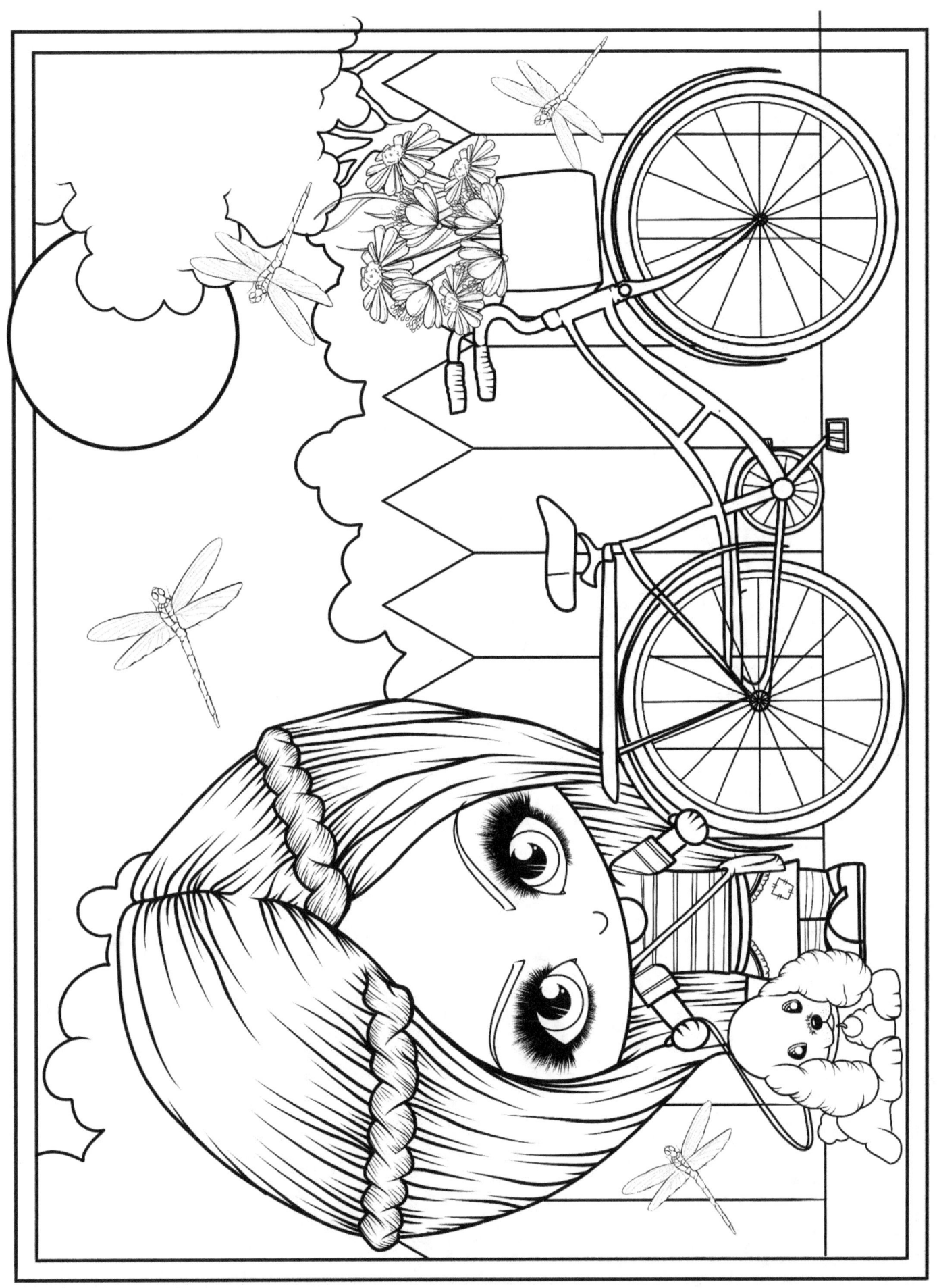

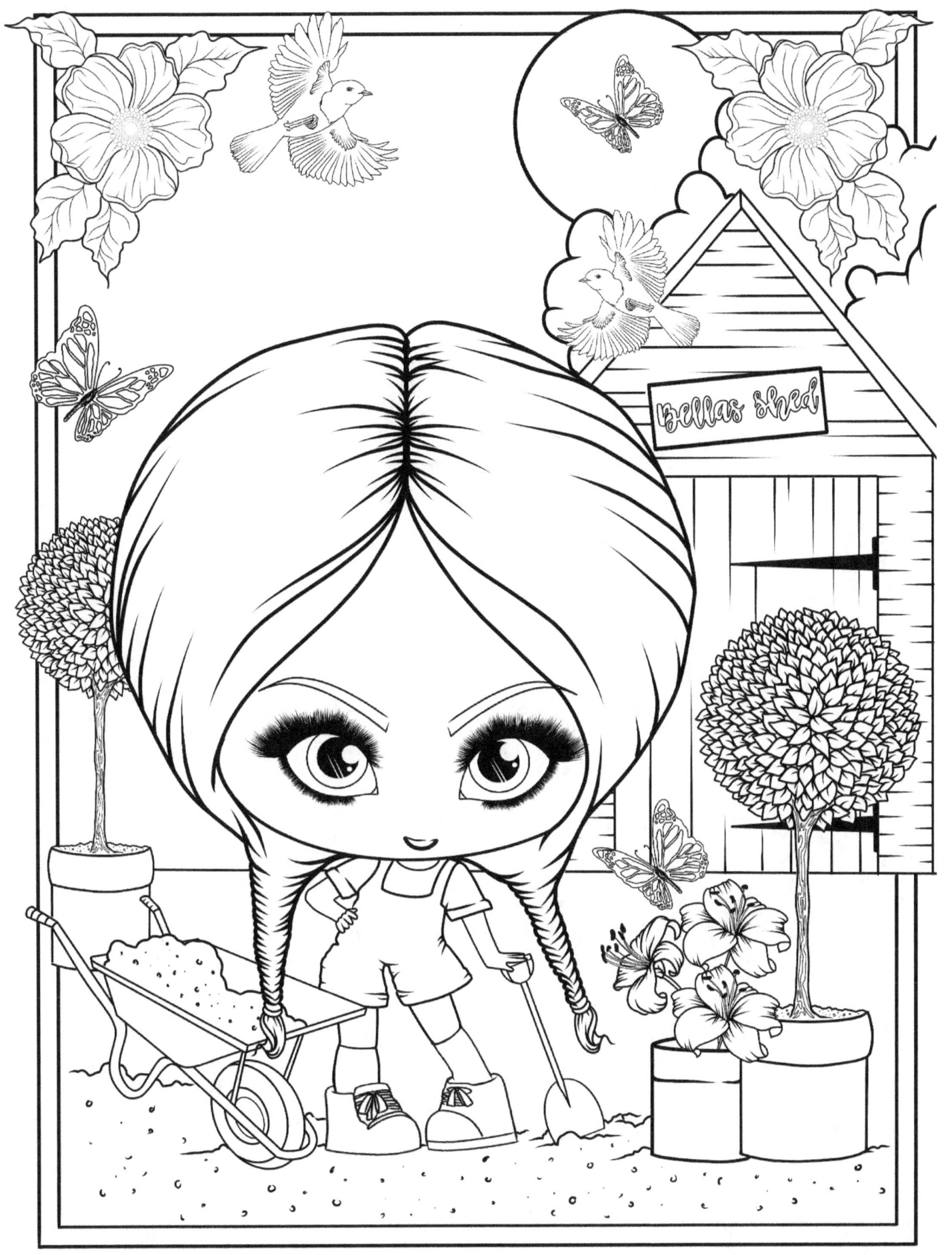

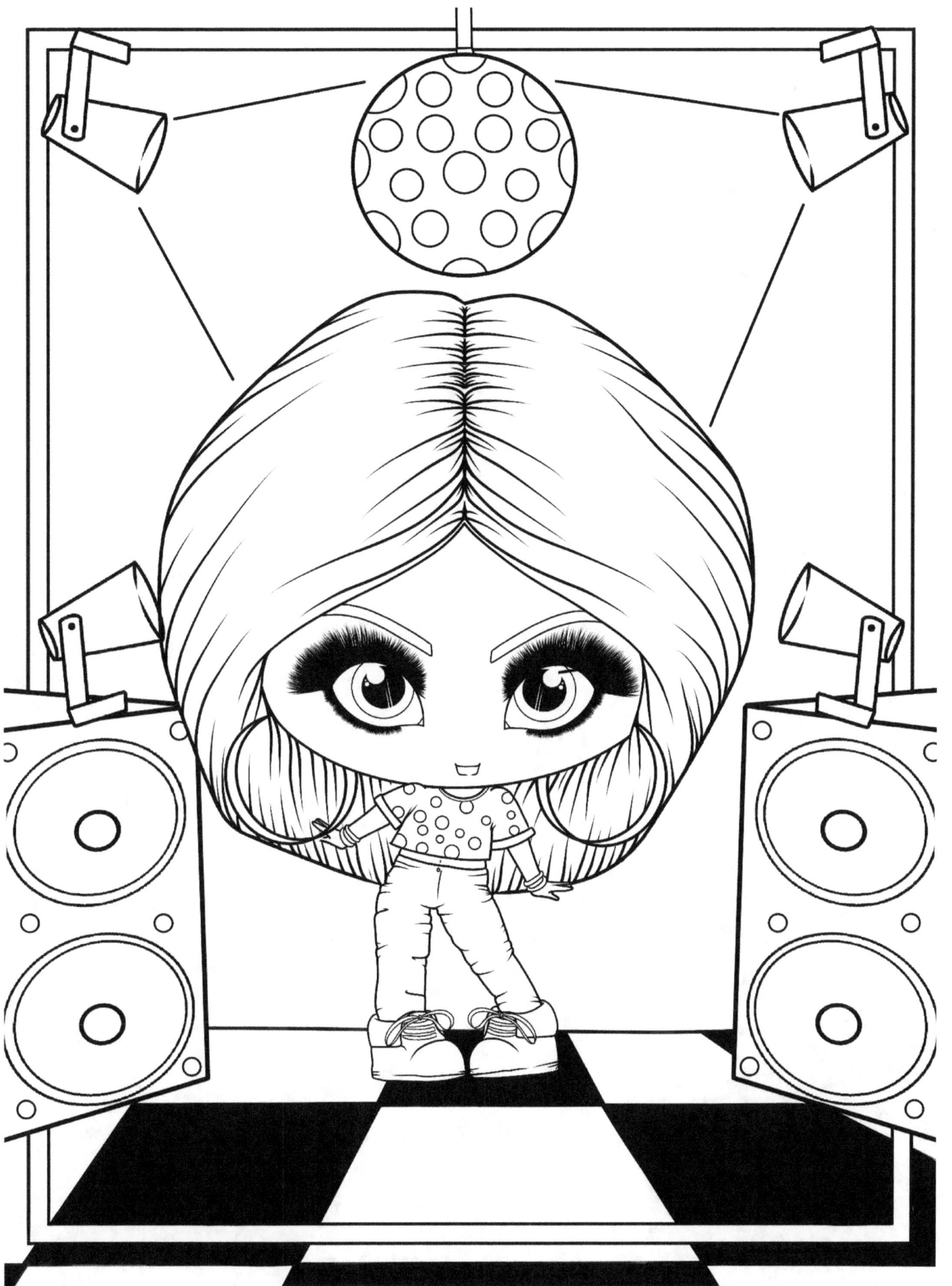

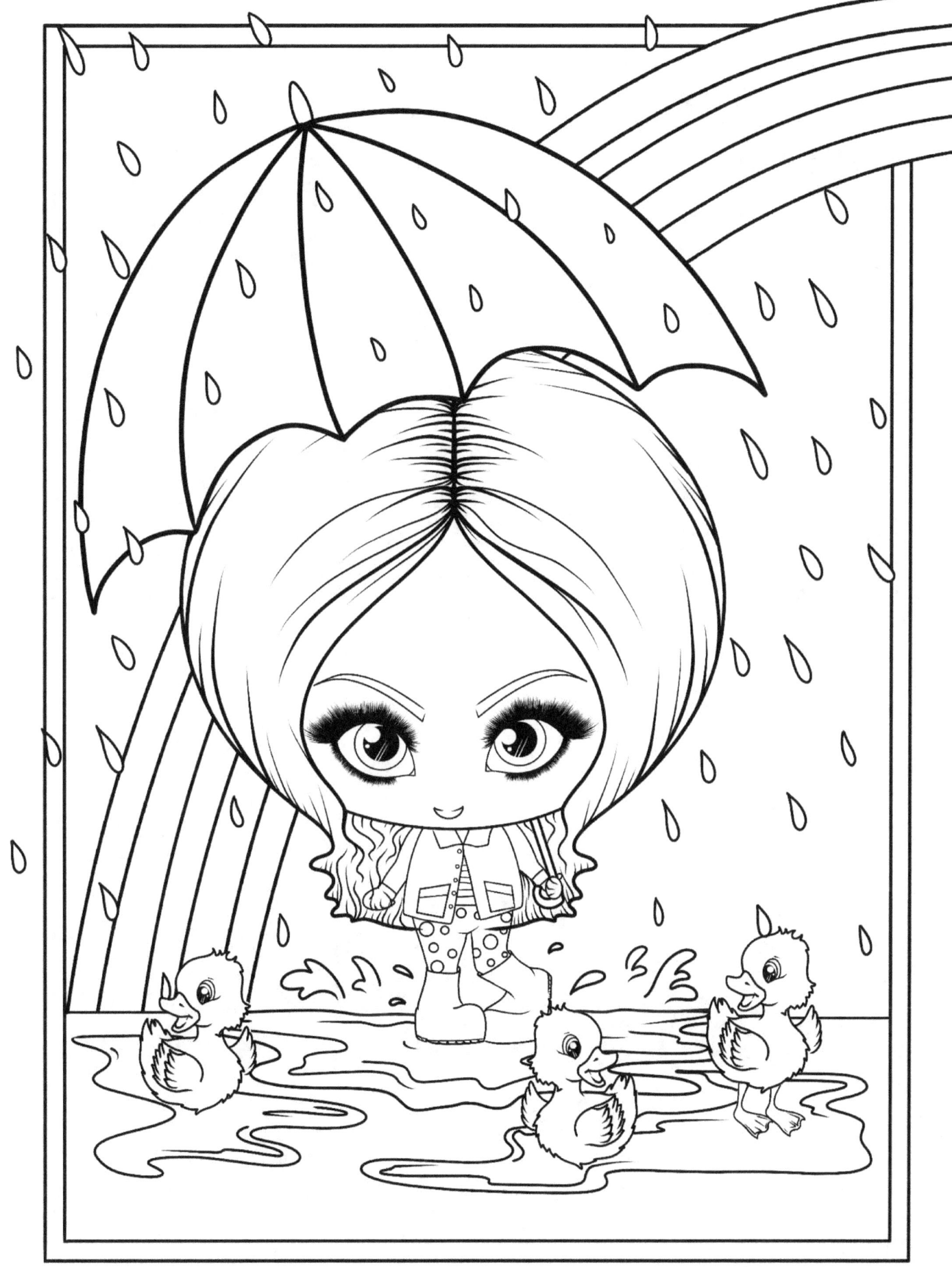

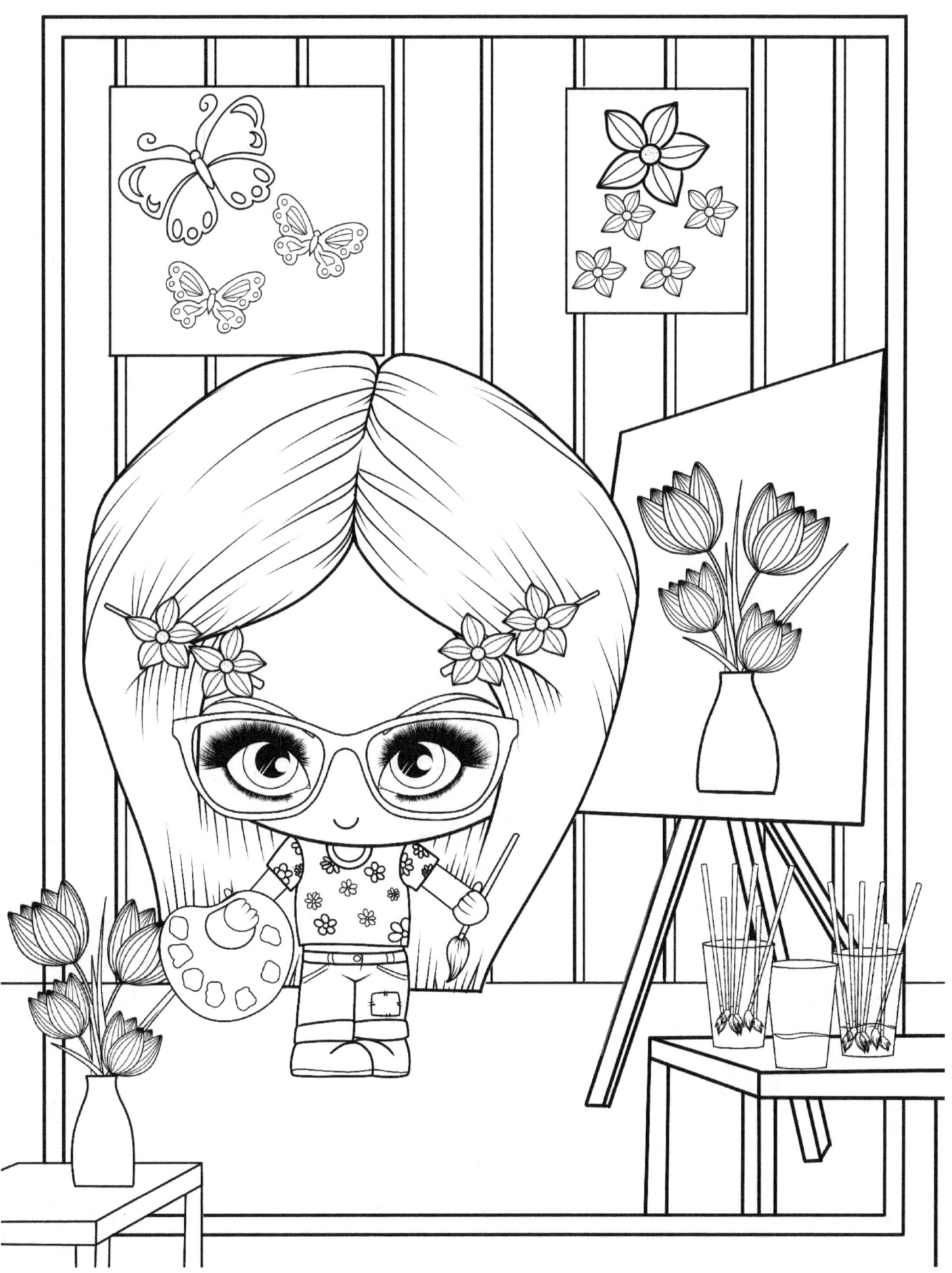

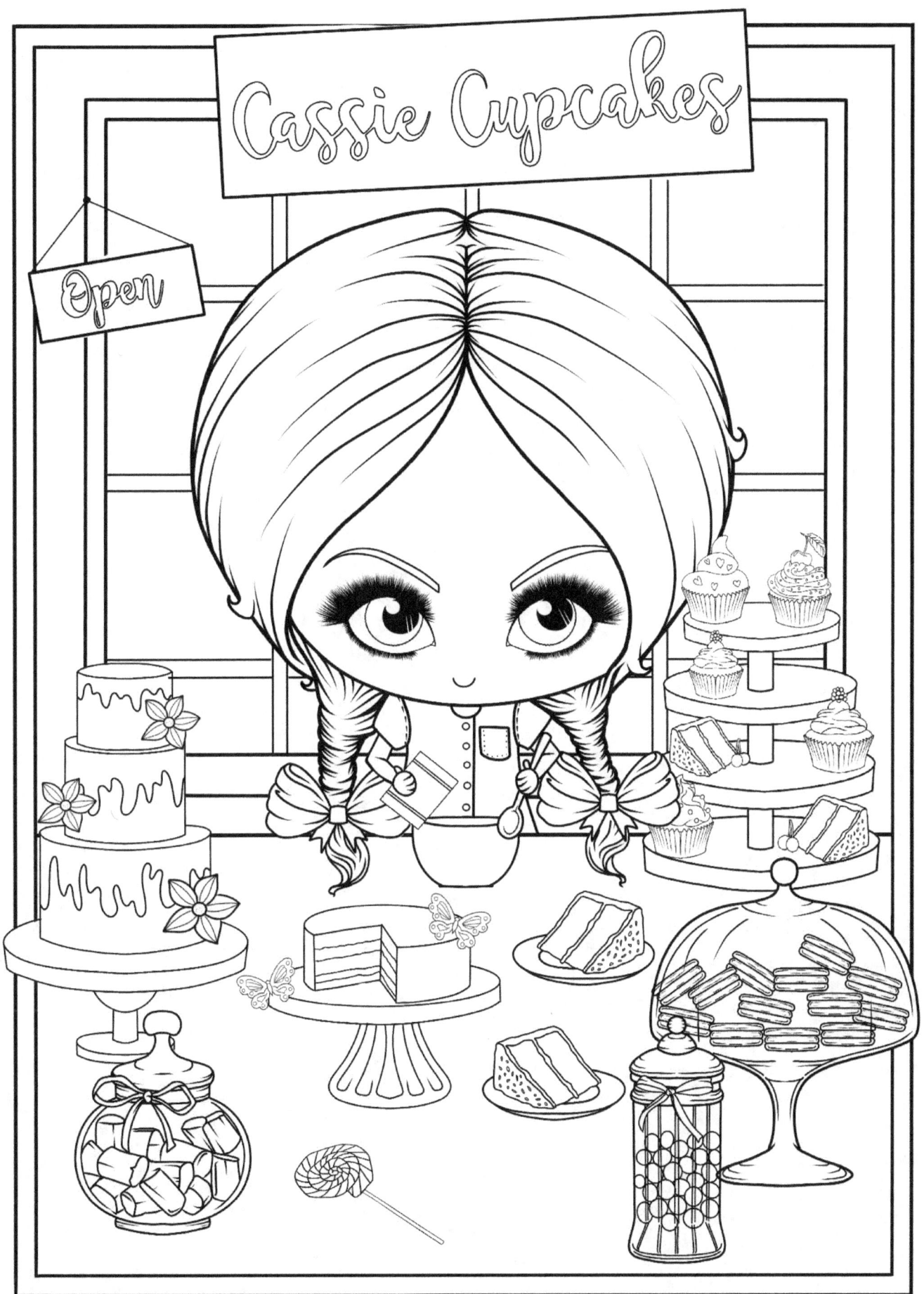

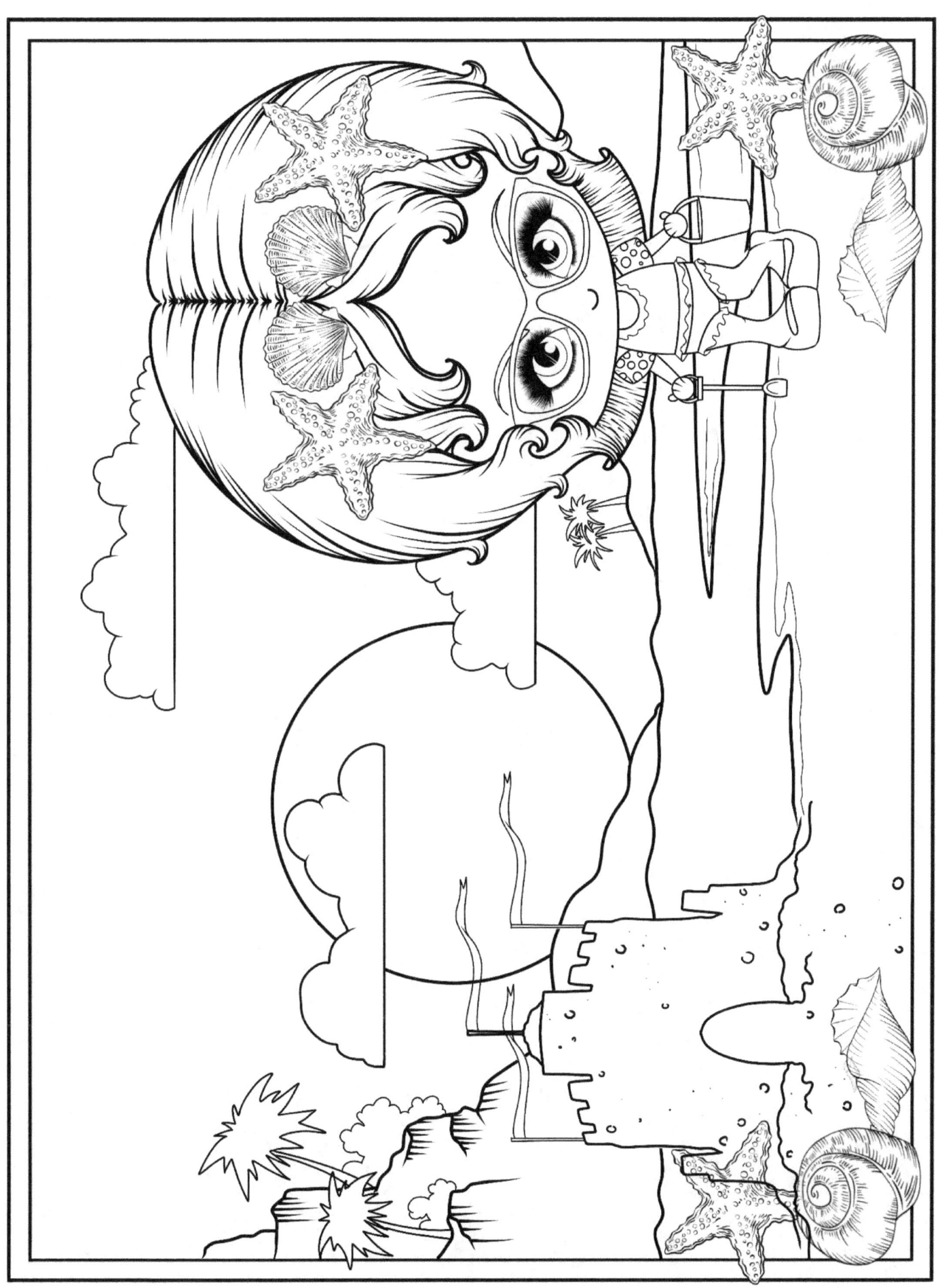

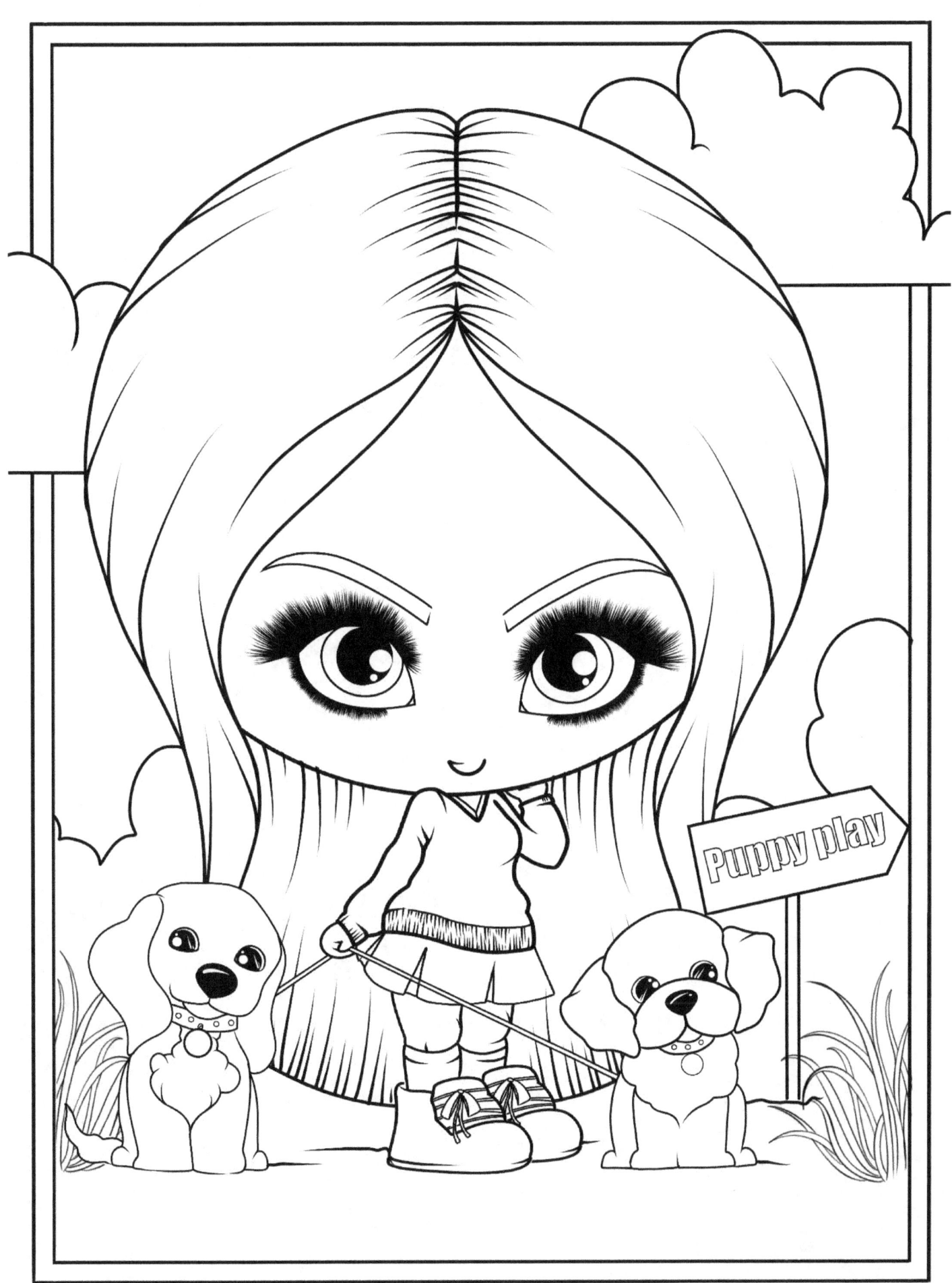

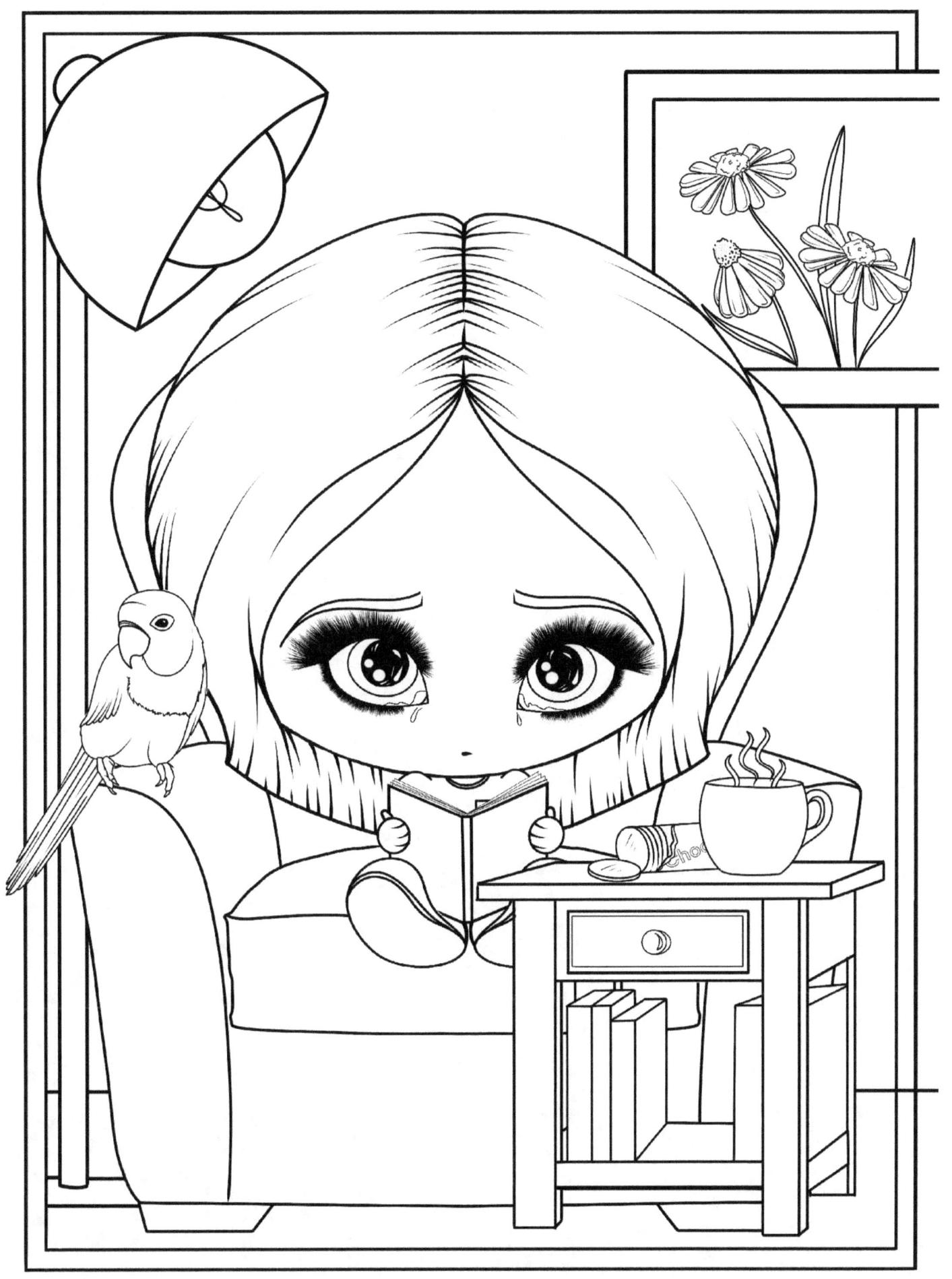

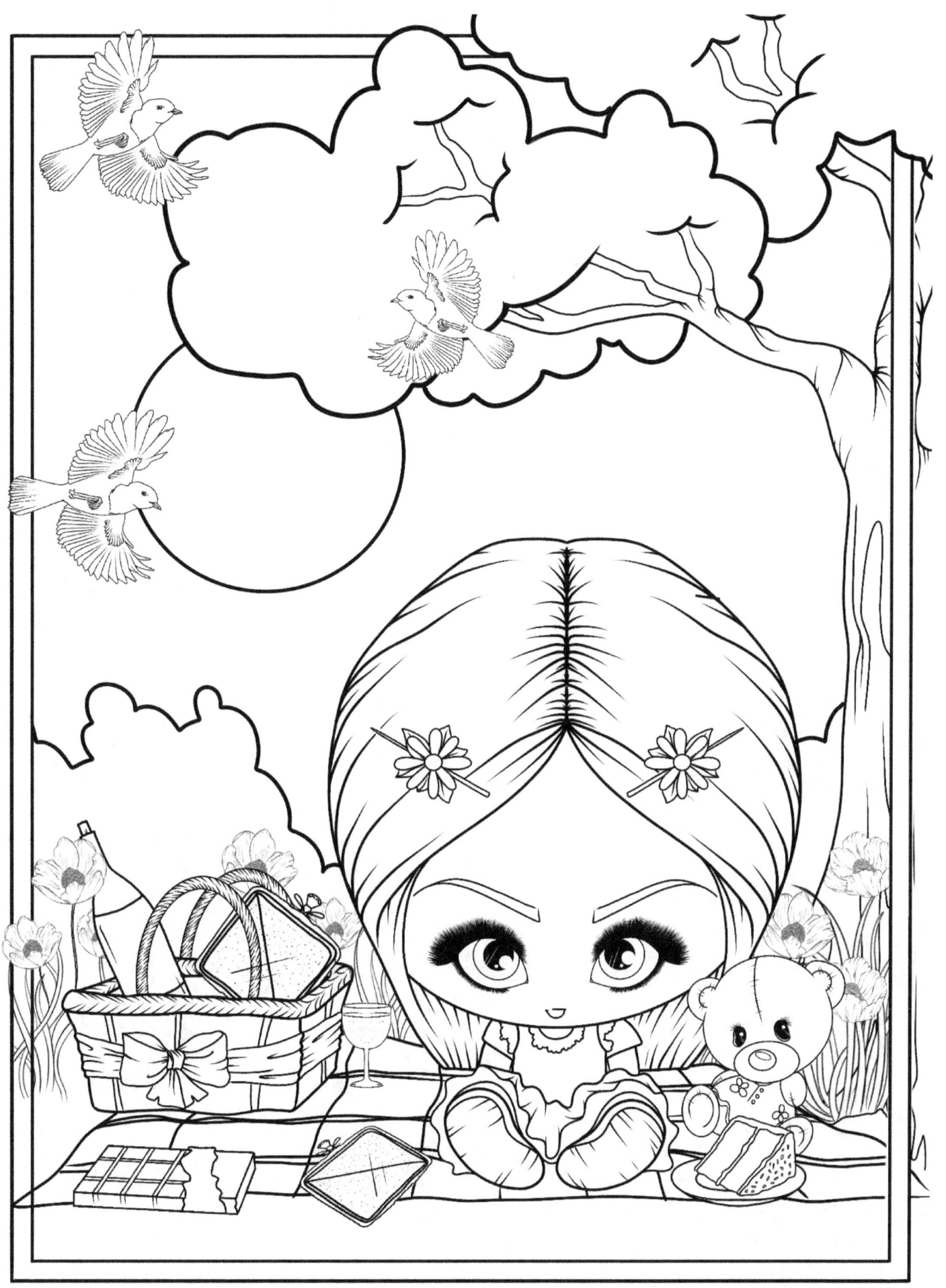

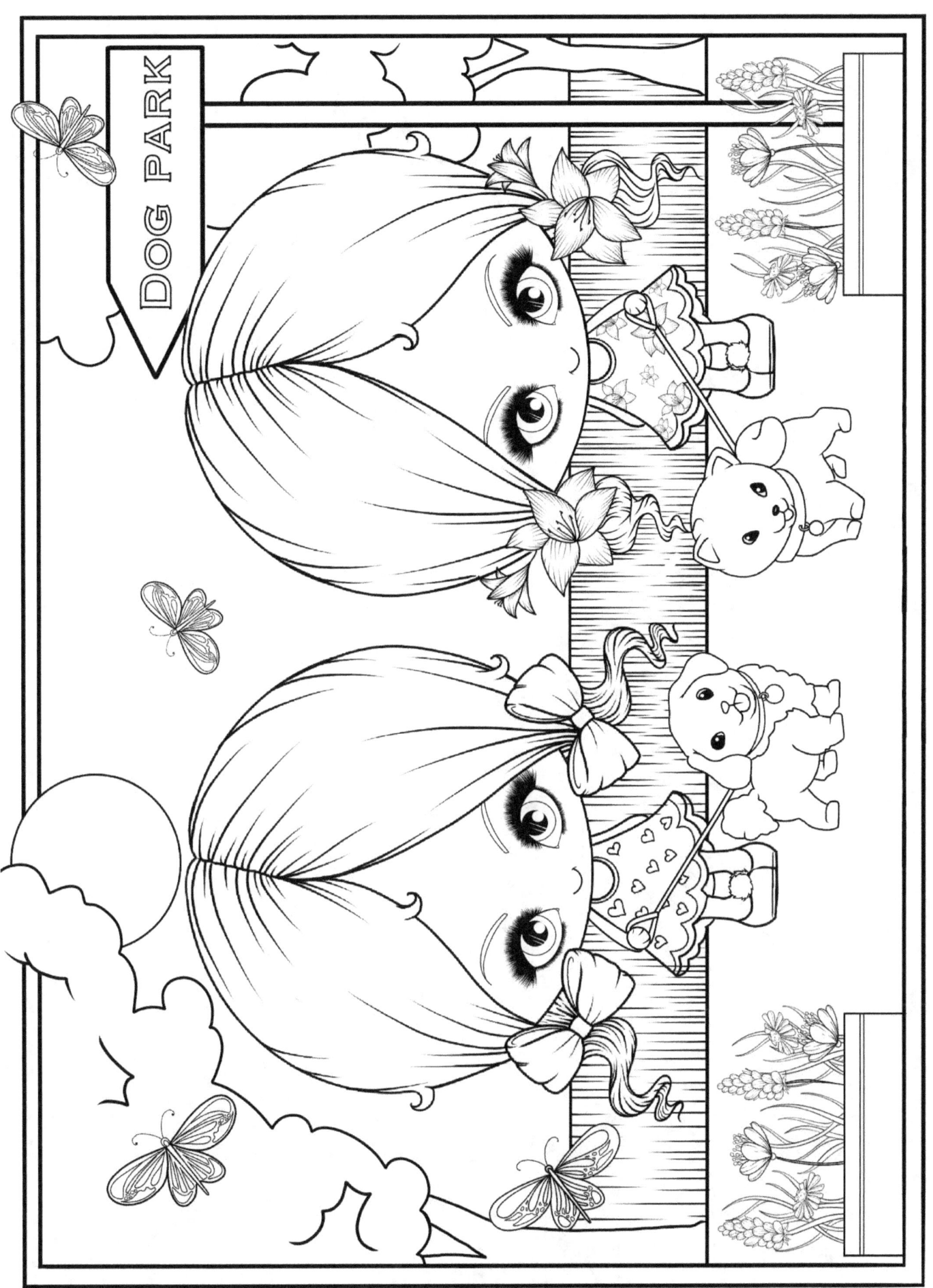

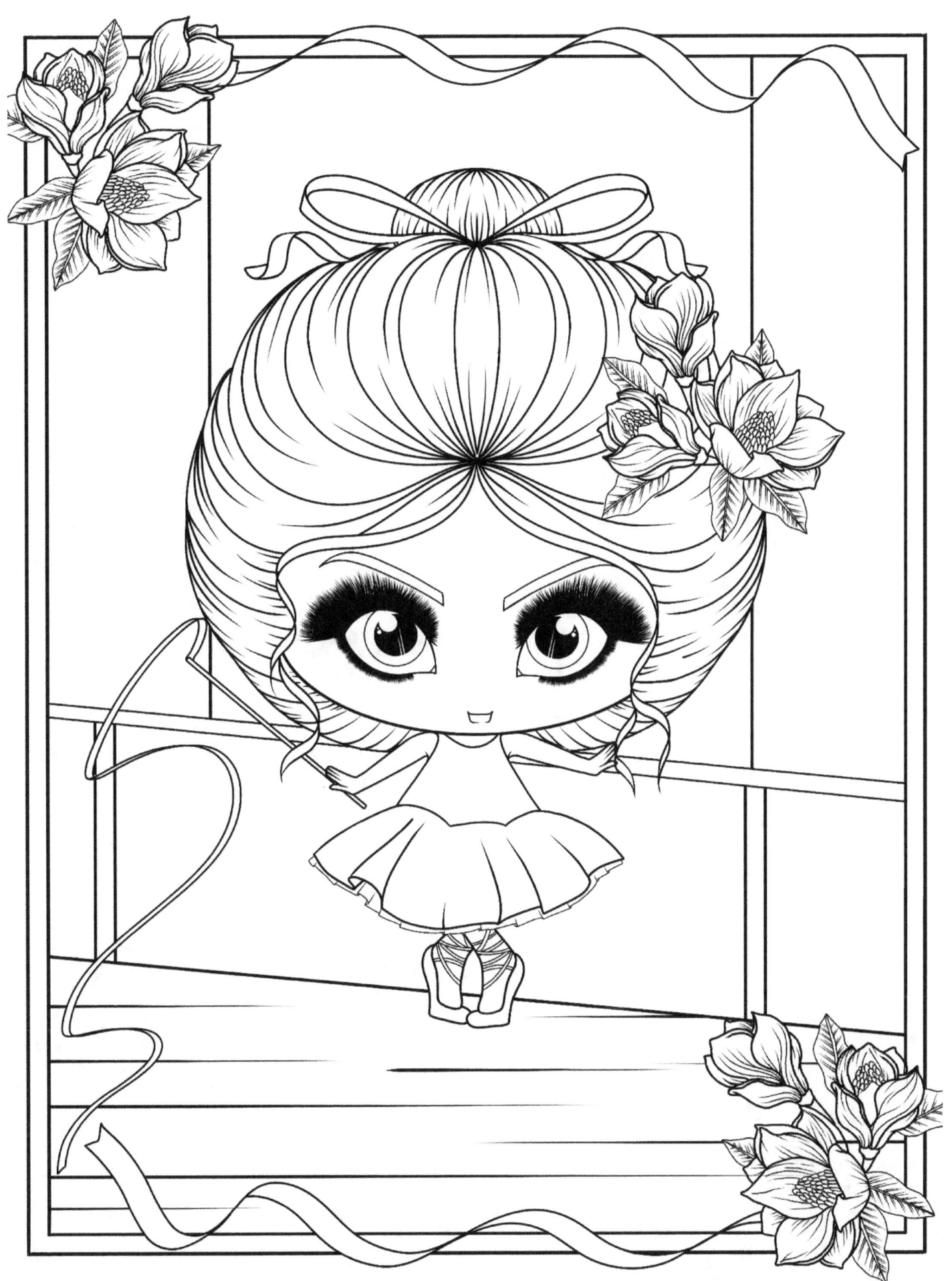

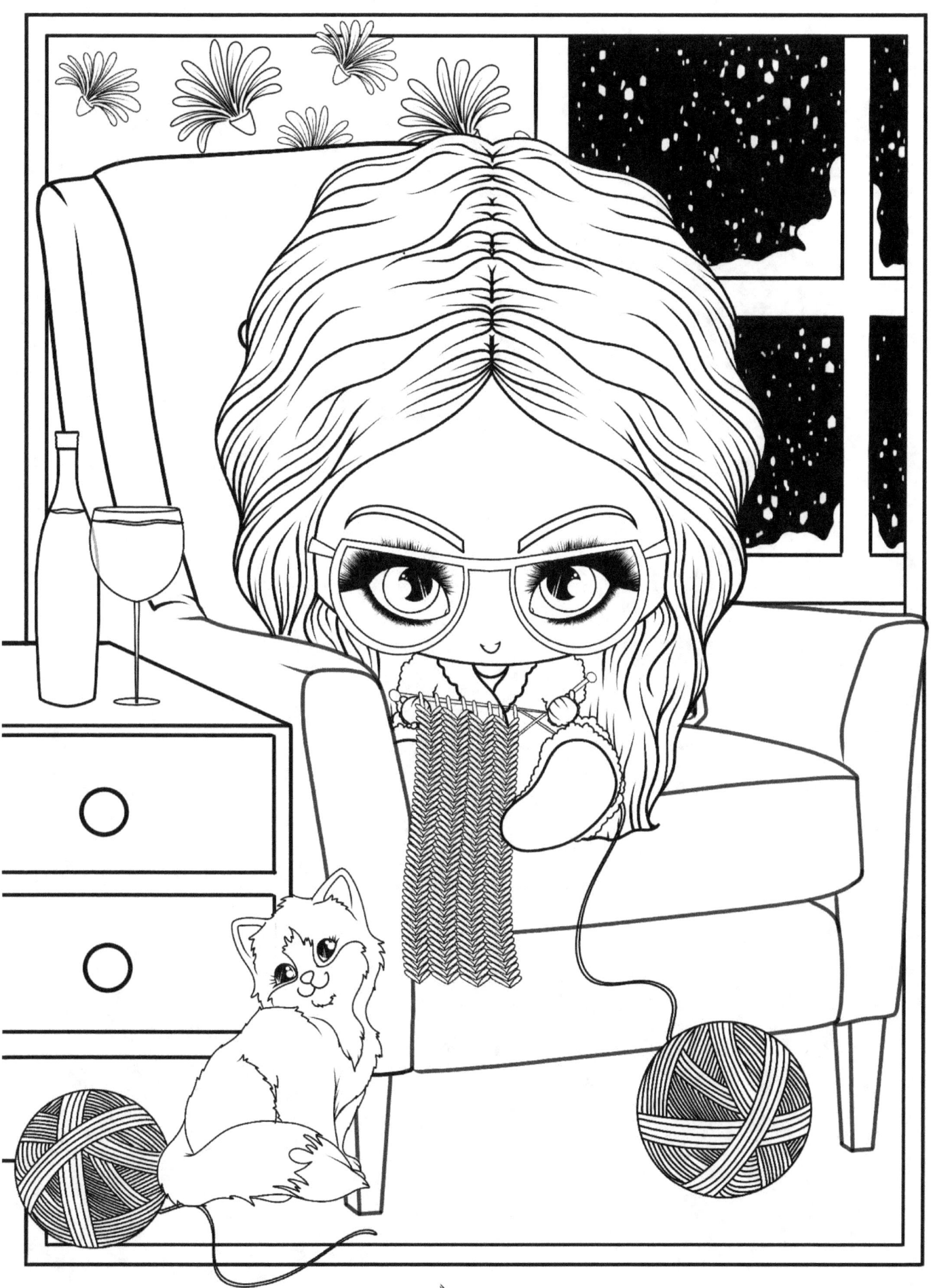

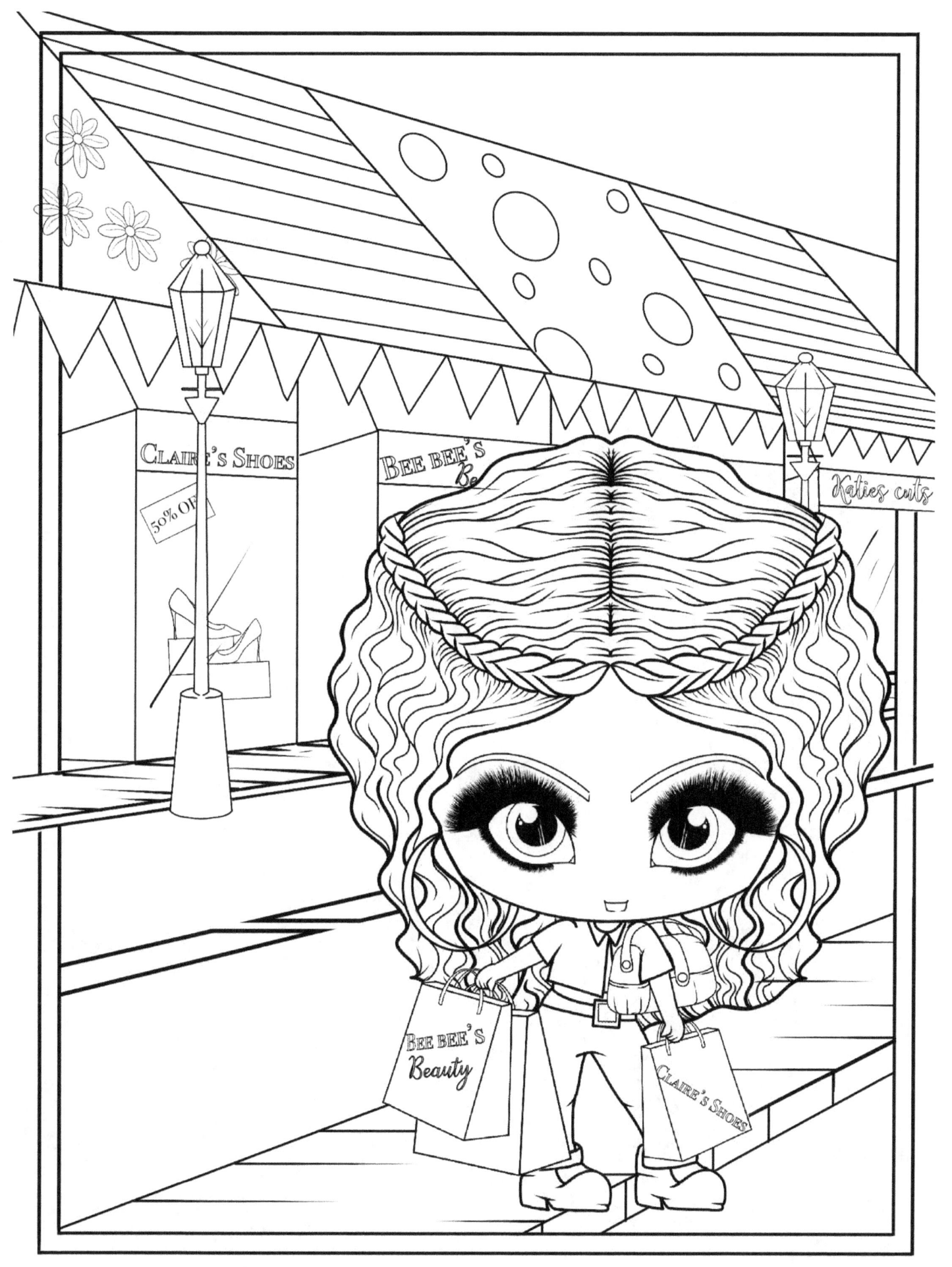

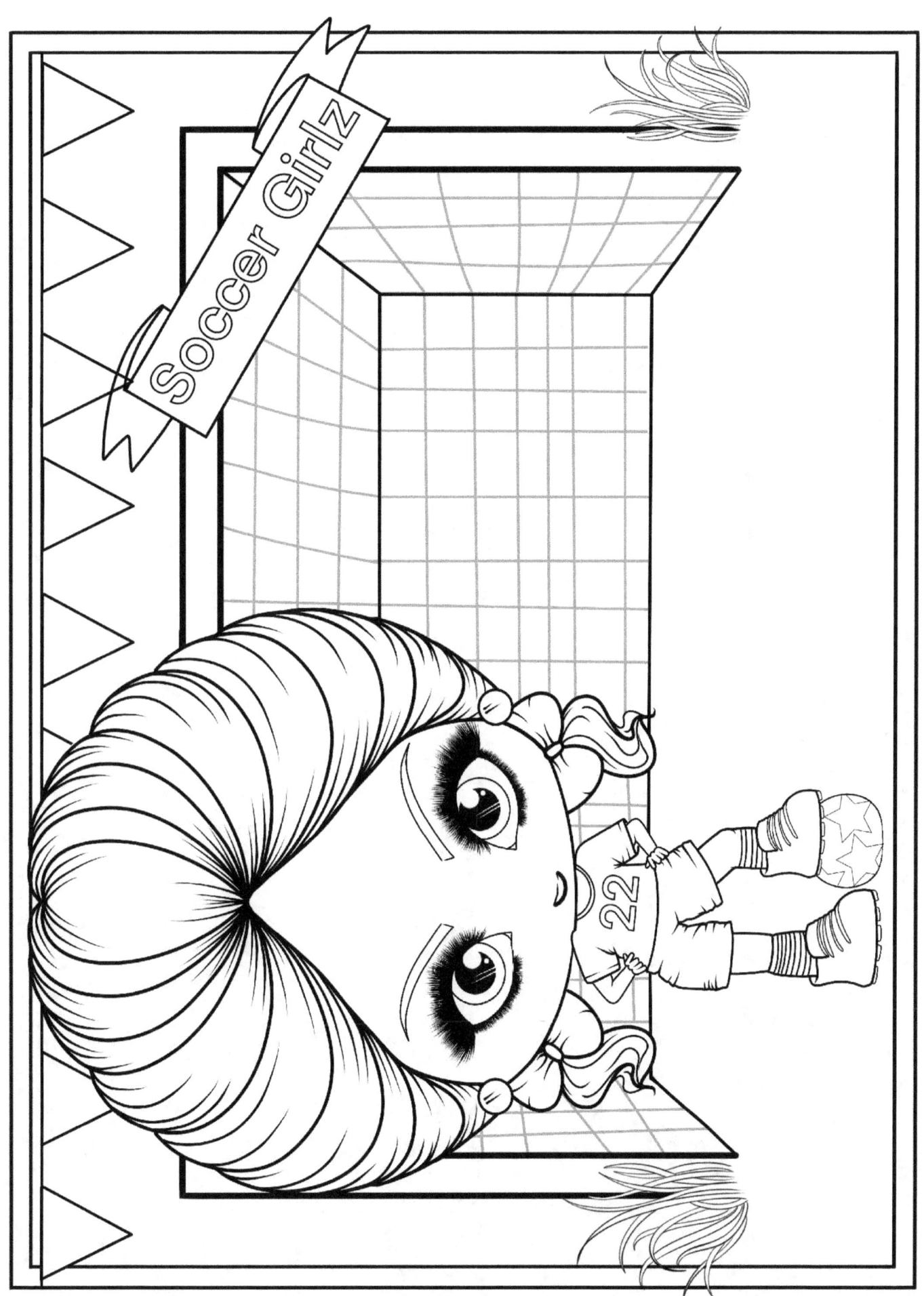

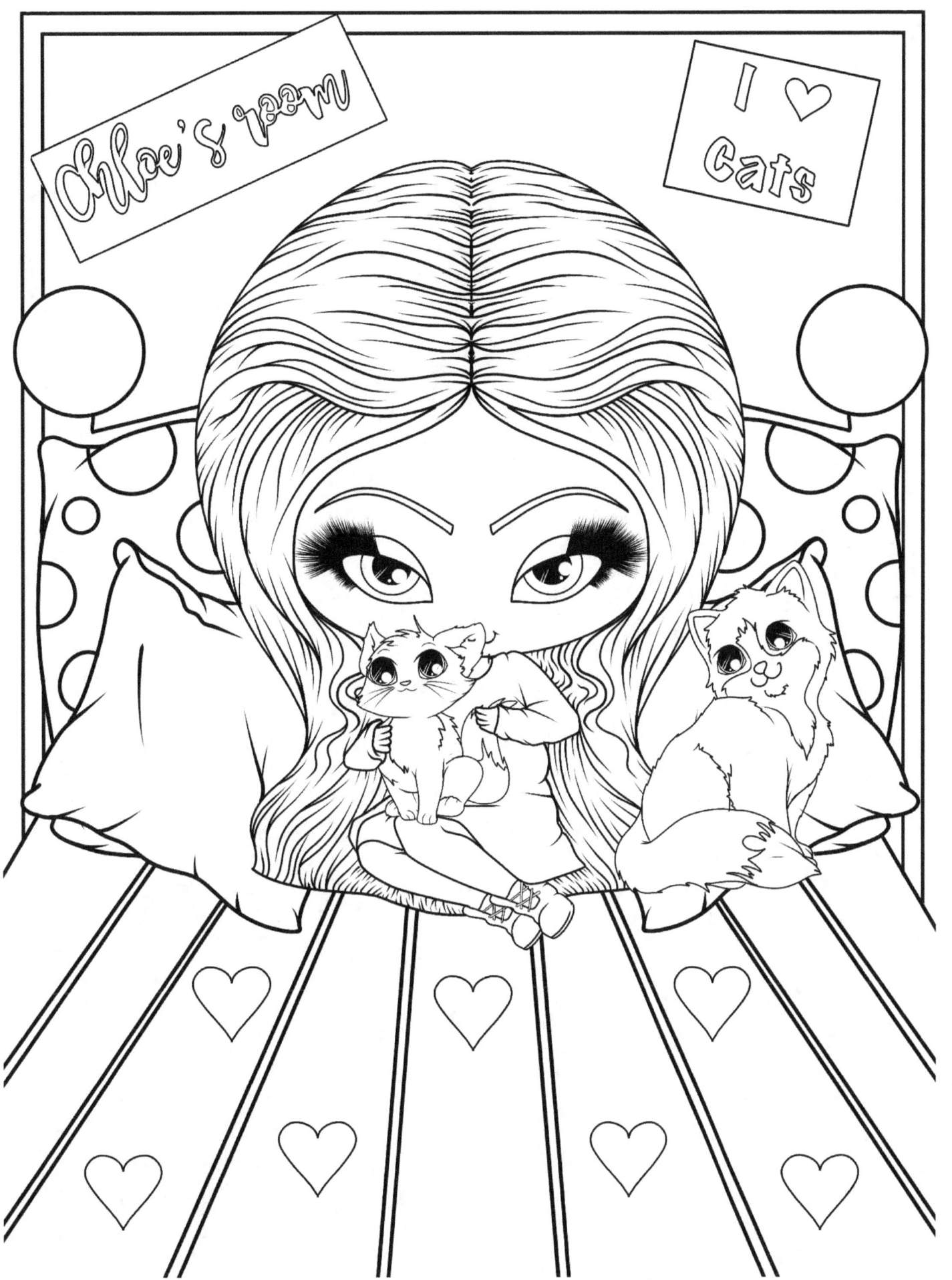

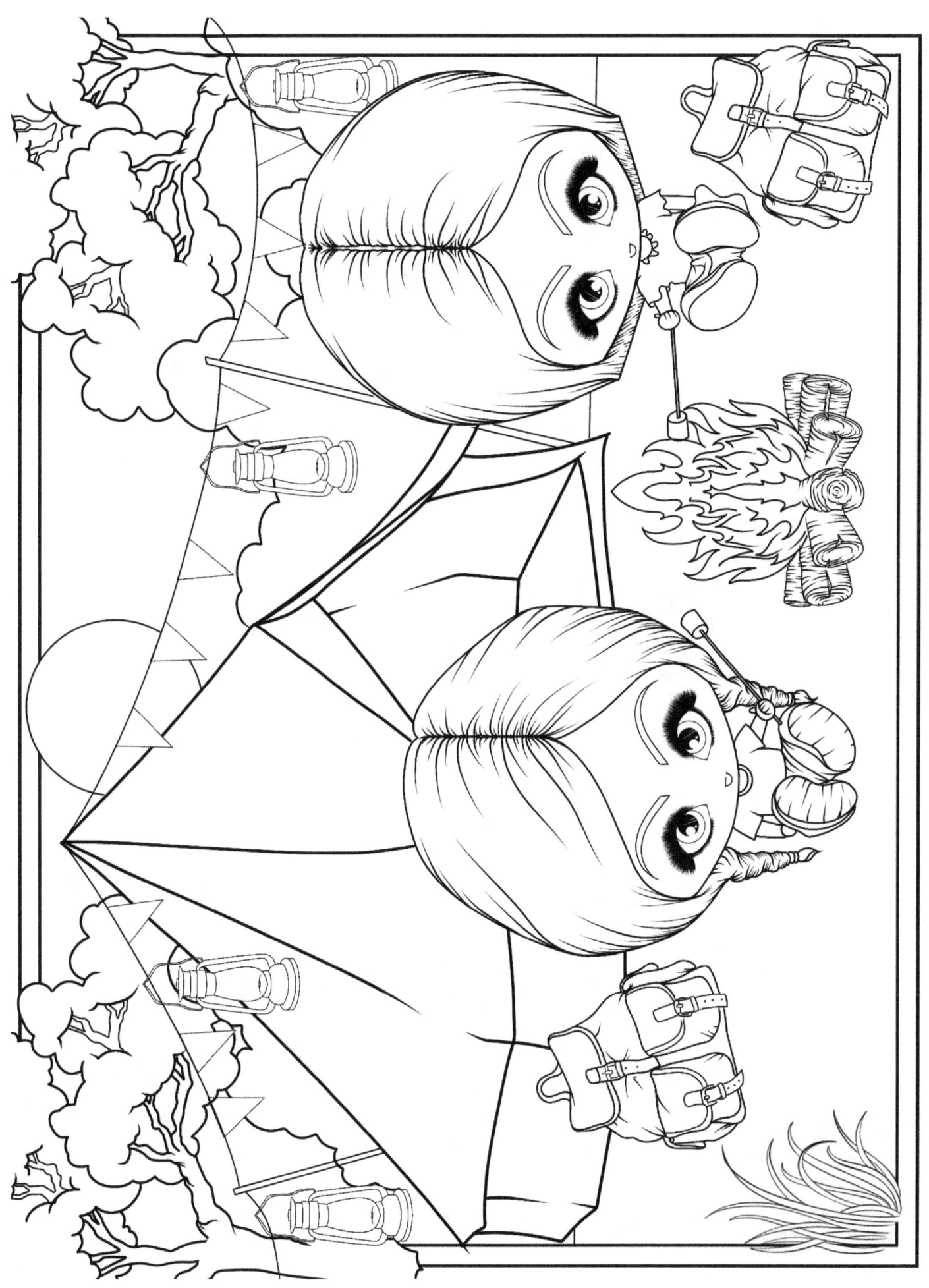

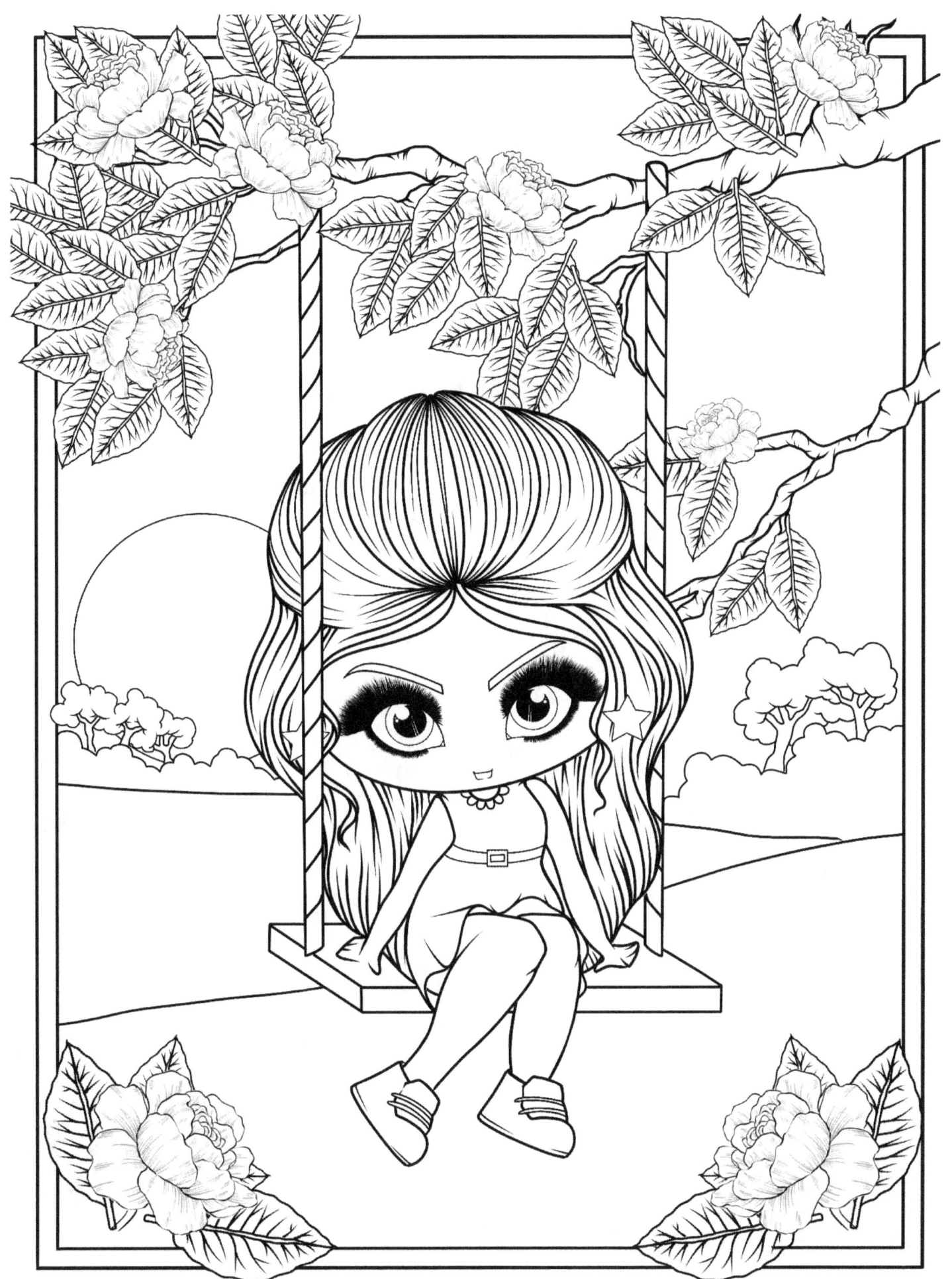

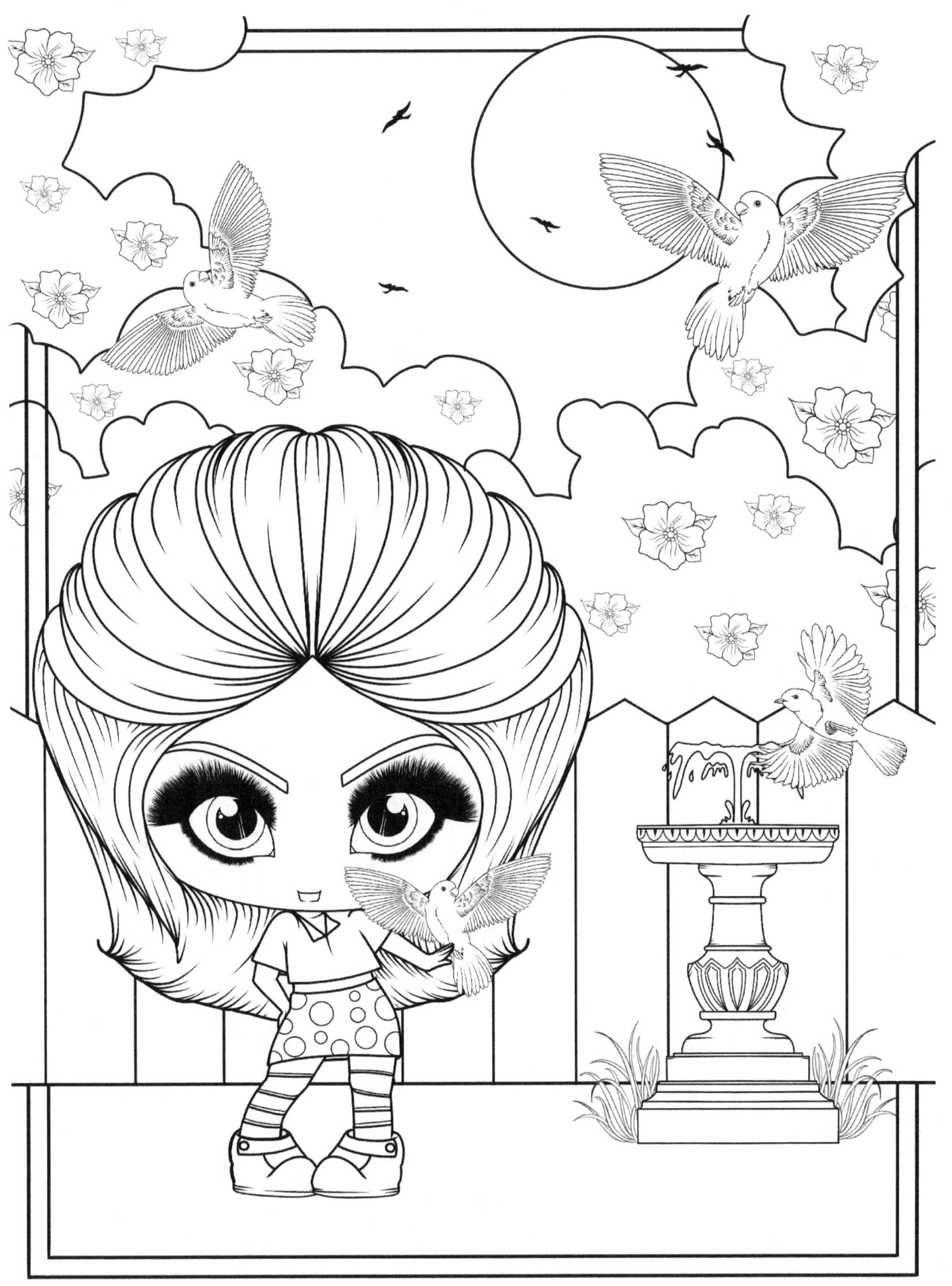

The Littlest Darlings

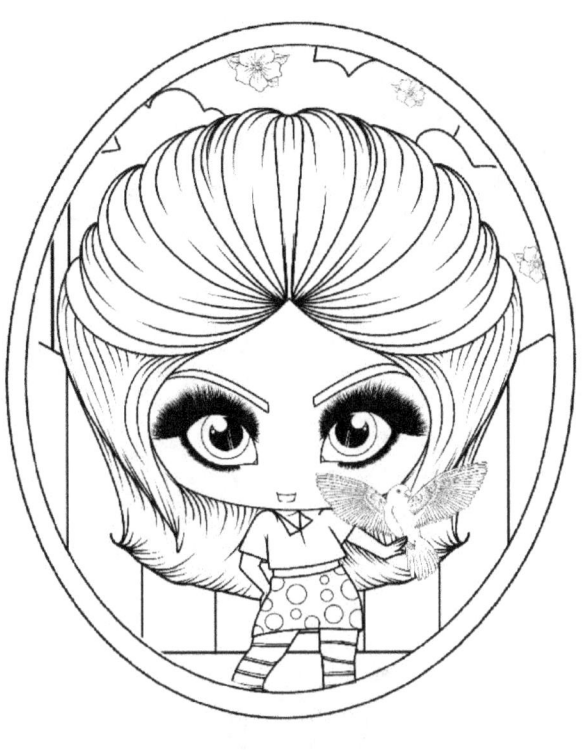

Jess Ruth

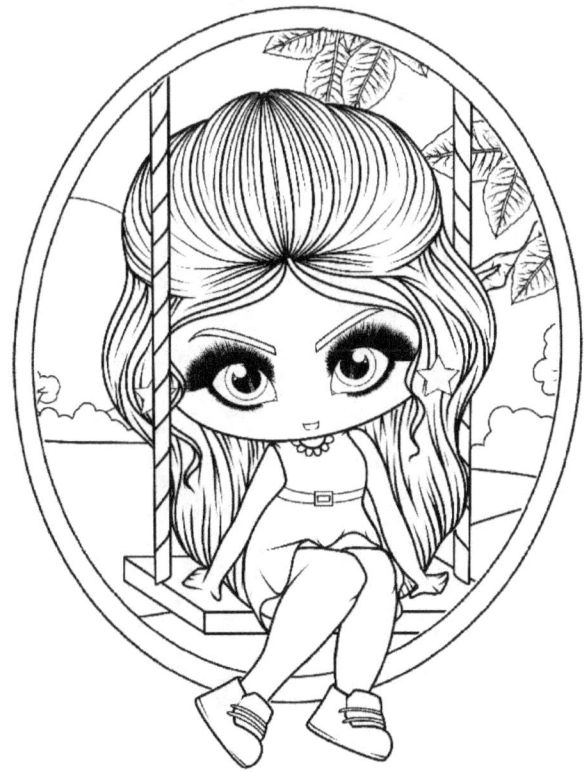

Kelly Claire

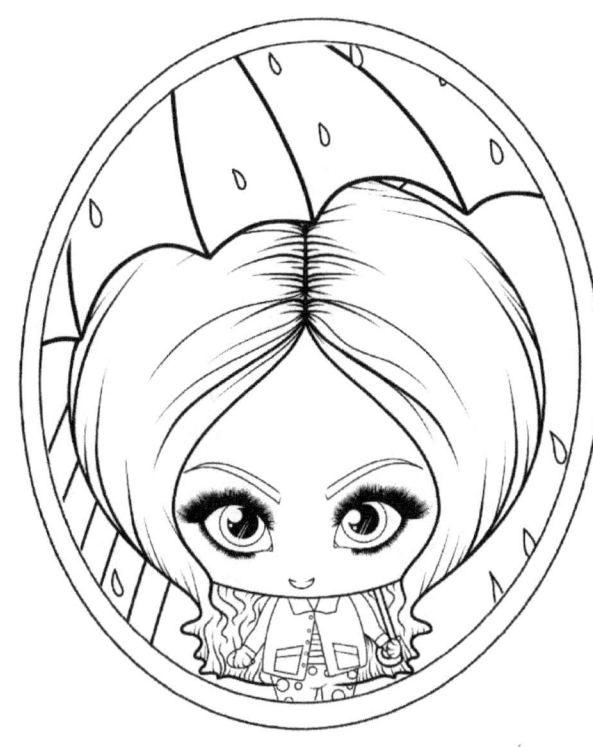

Summer Rain

Emma Jane

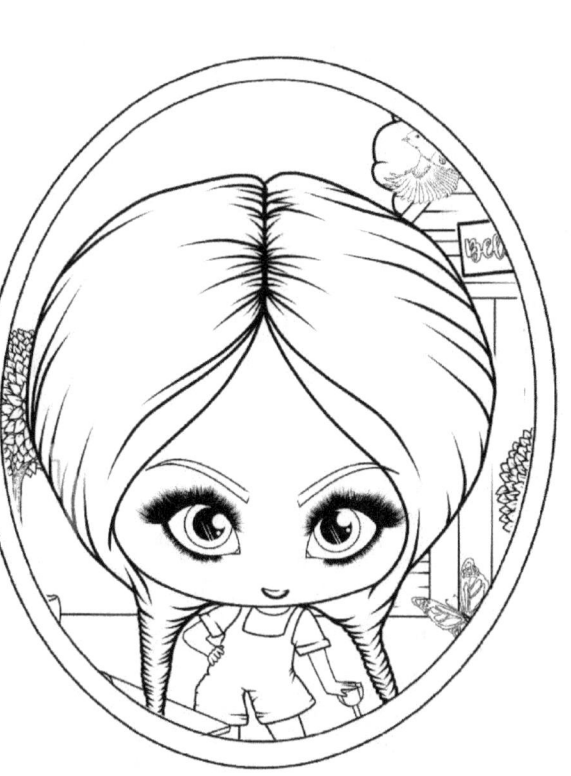

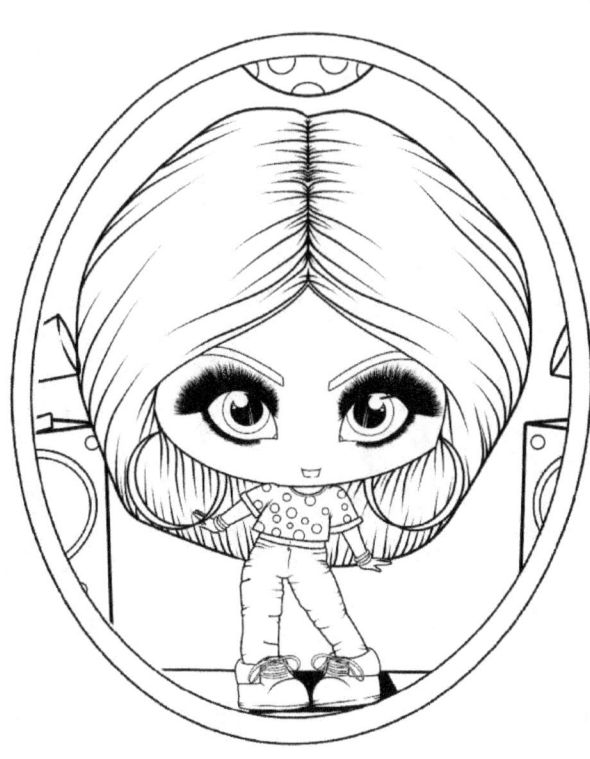

Dina Disco

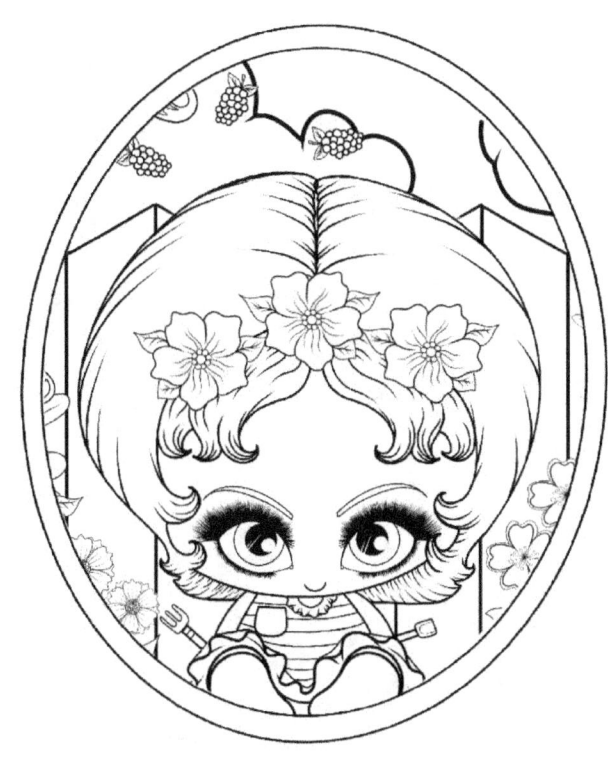

Poppy Petal

Daisy Draw

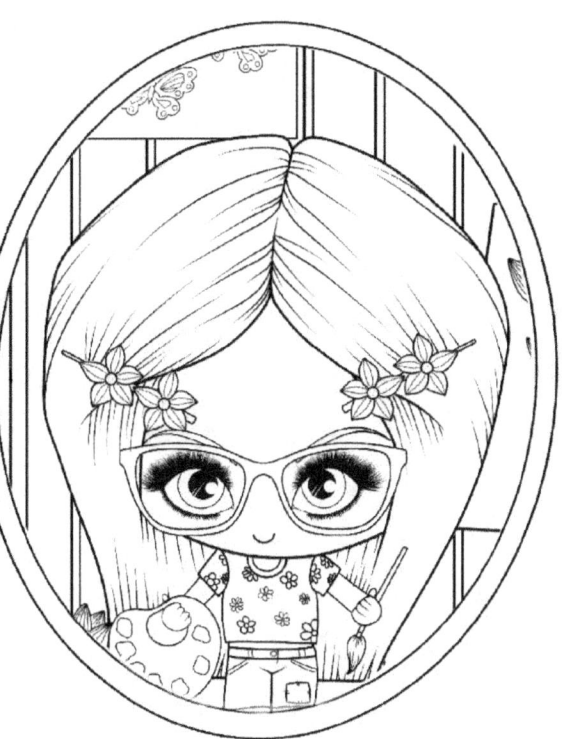

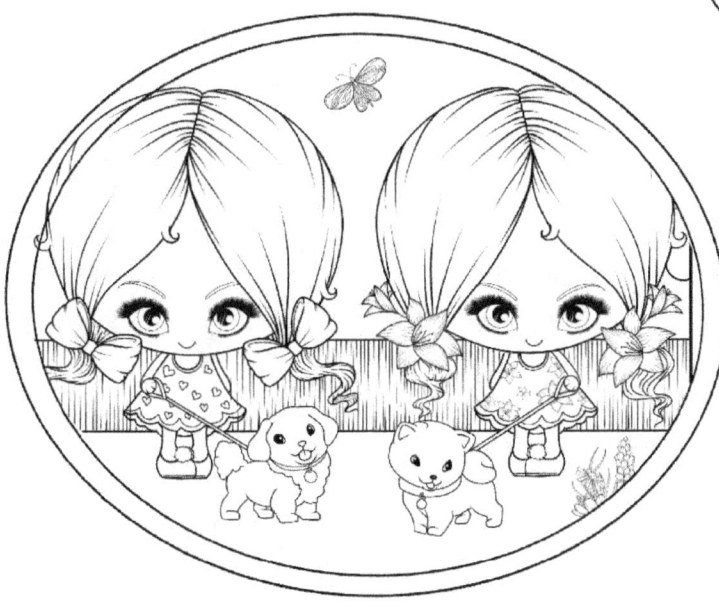

Kiki and Cocoa

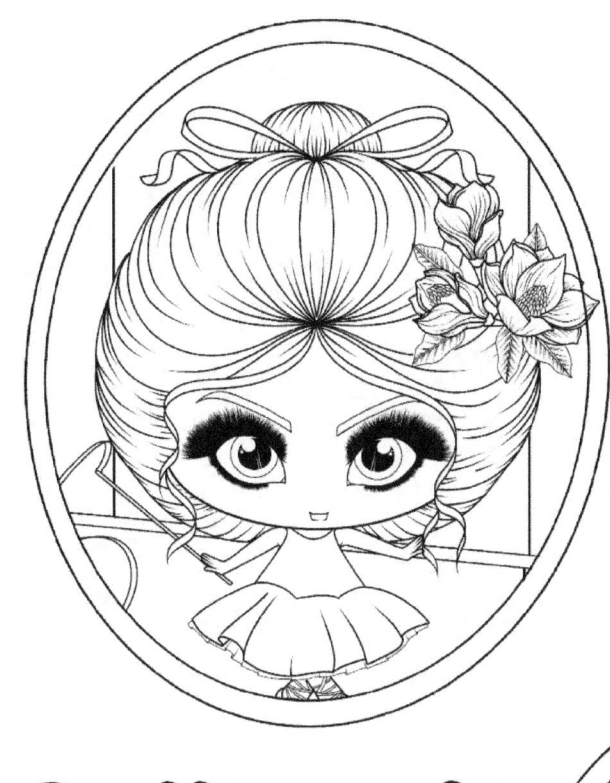

Amy Lee

Dotty and Debbie

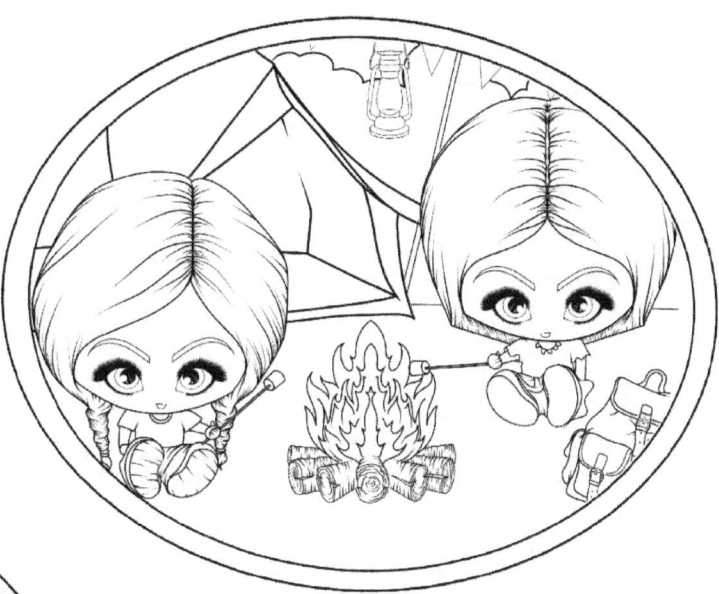

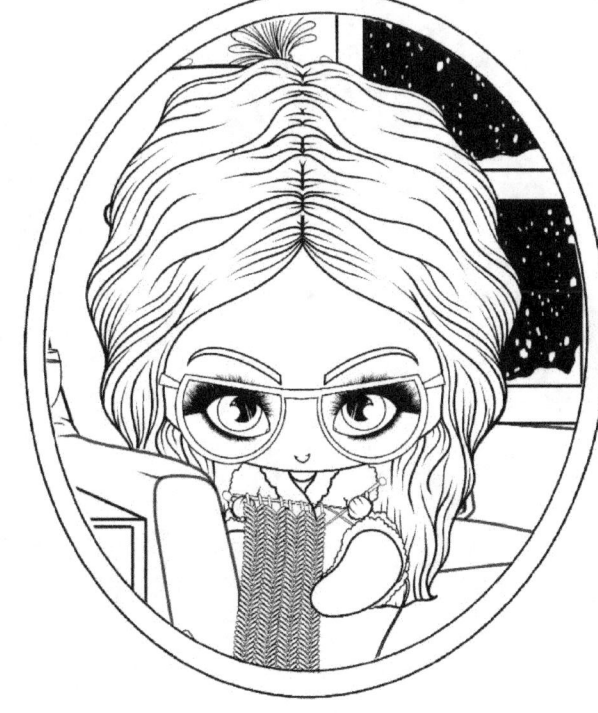

Nancy knits

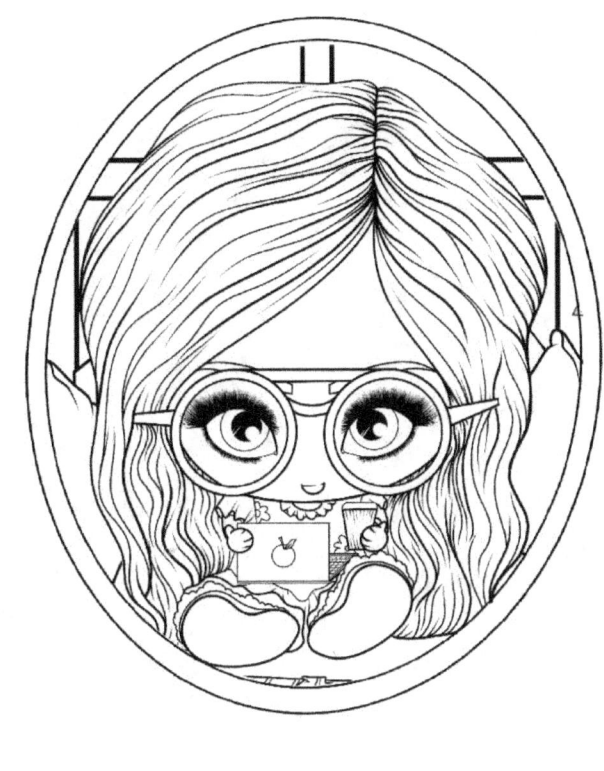

Suzie Kaye

Becky Beach

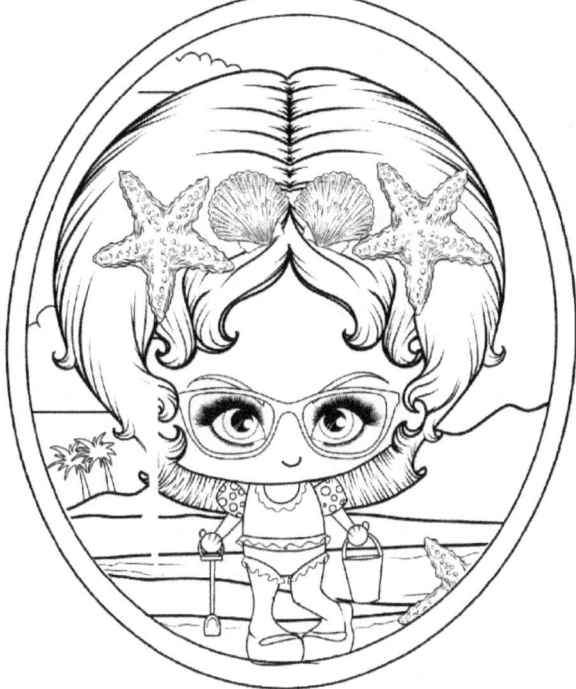

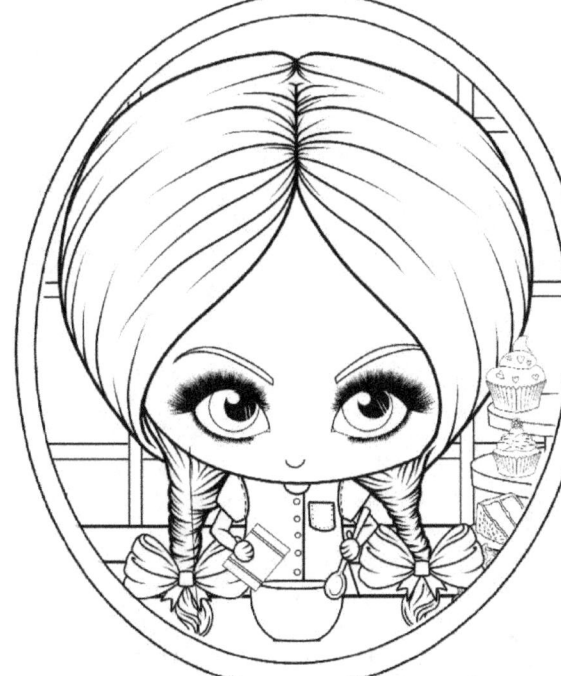

Cassie Cupcakes

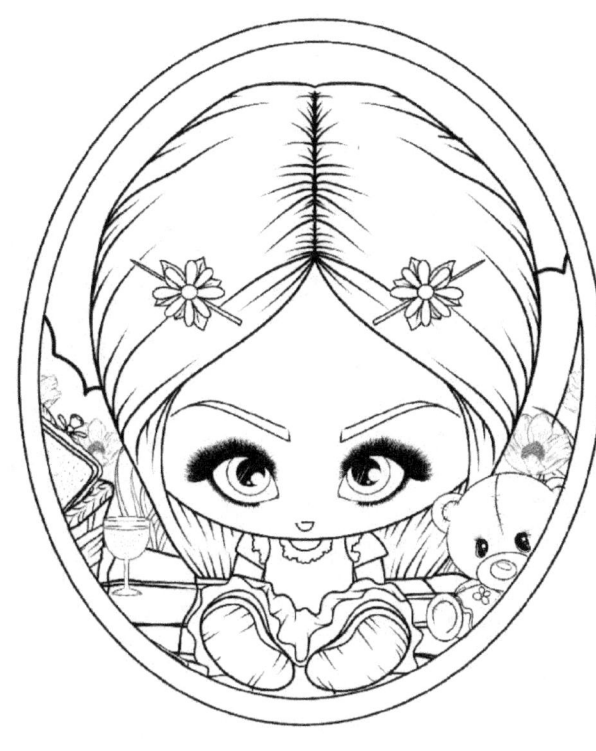

Olivia Amy

Elsie Parks

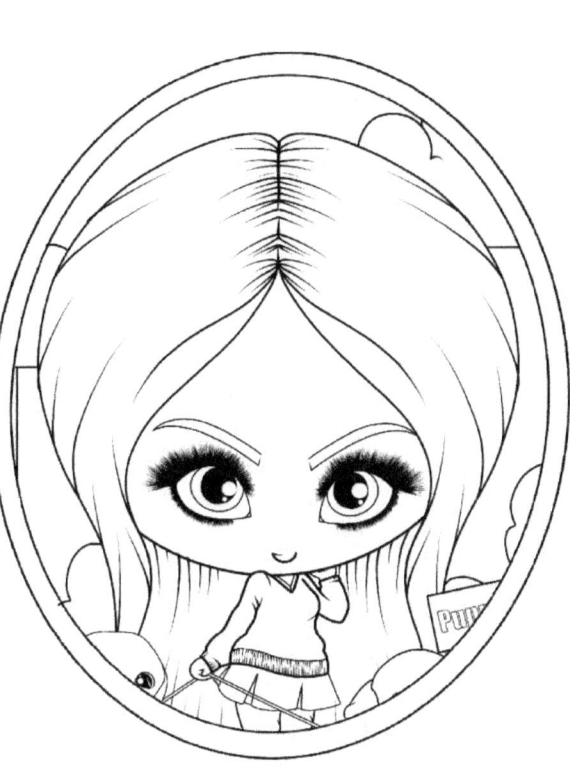

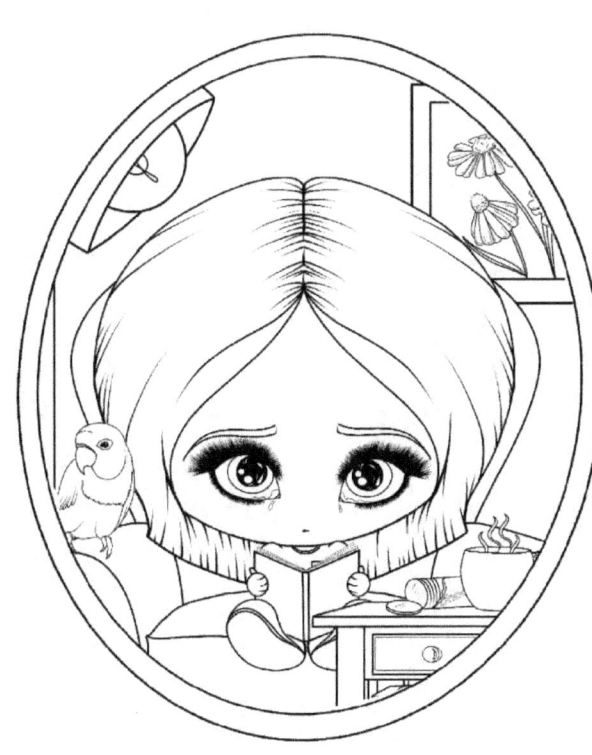

Jessica Jade

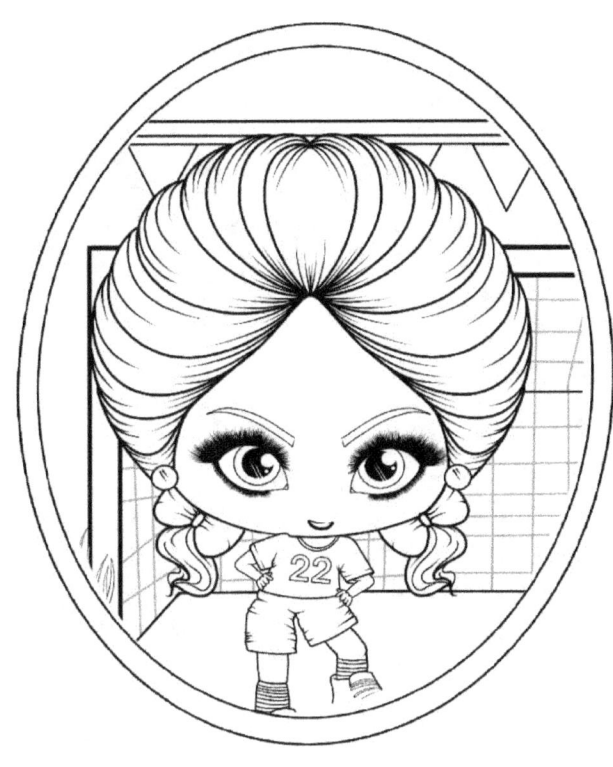

Teddy Jade

Sophie Nicole

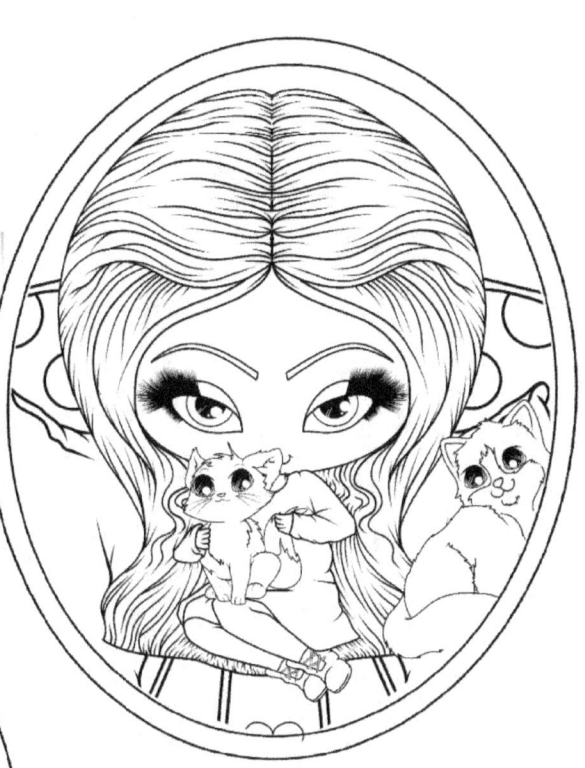

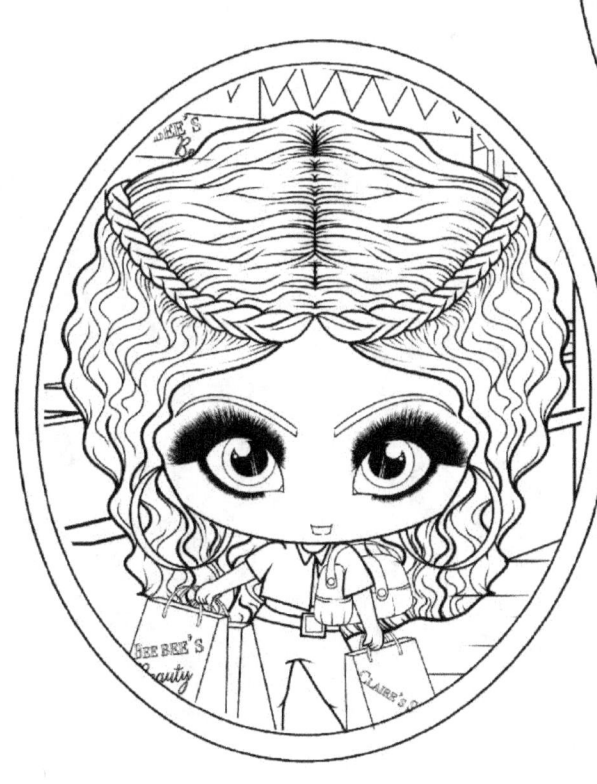

Sommer Elisha

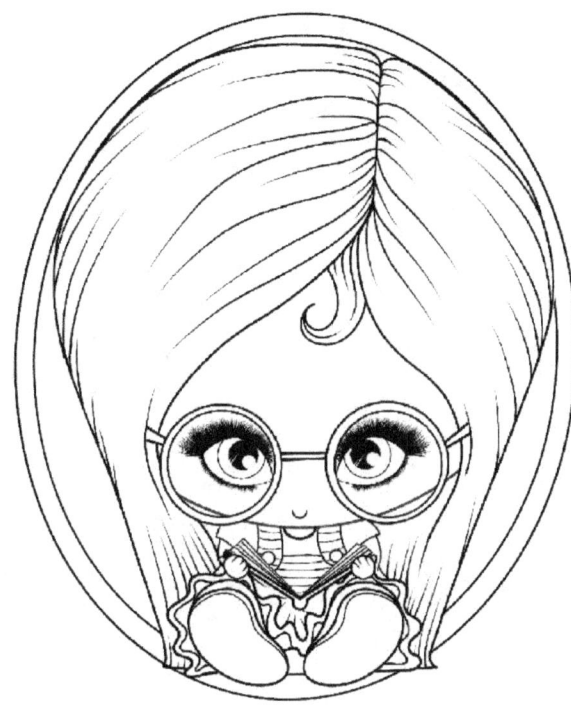

Sally Story

Lucy Star

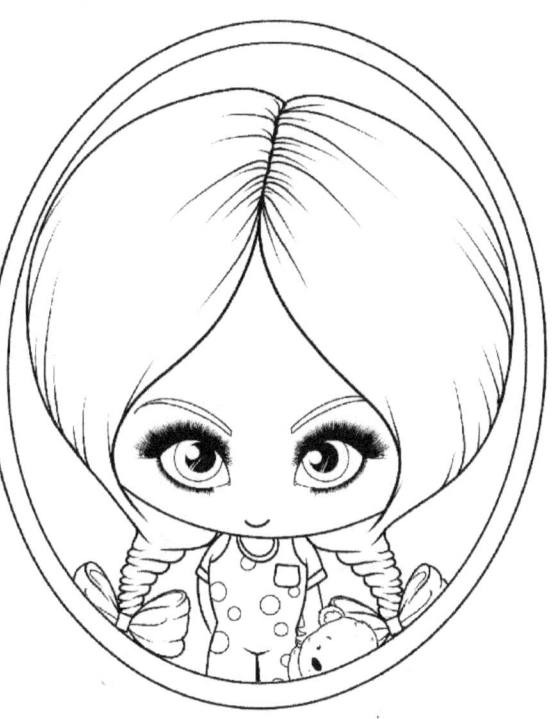

Katie Lou

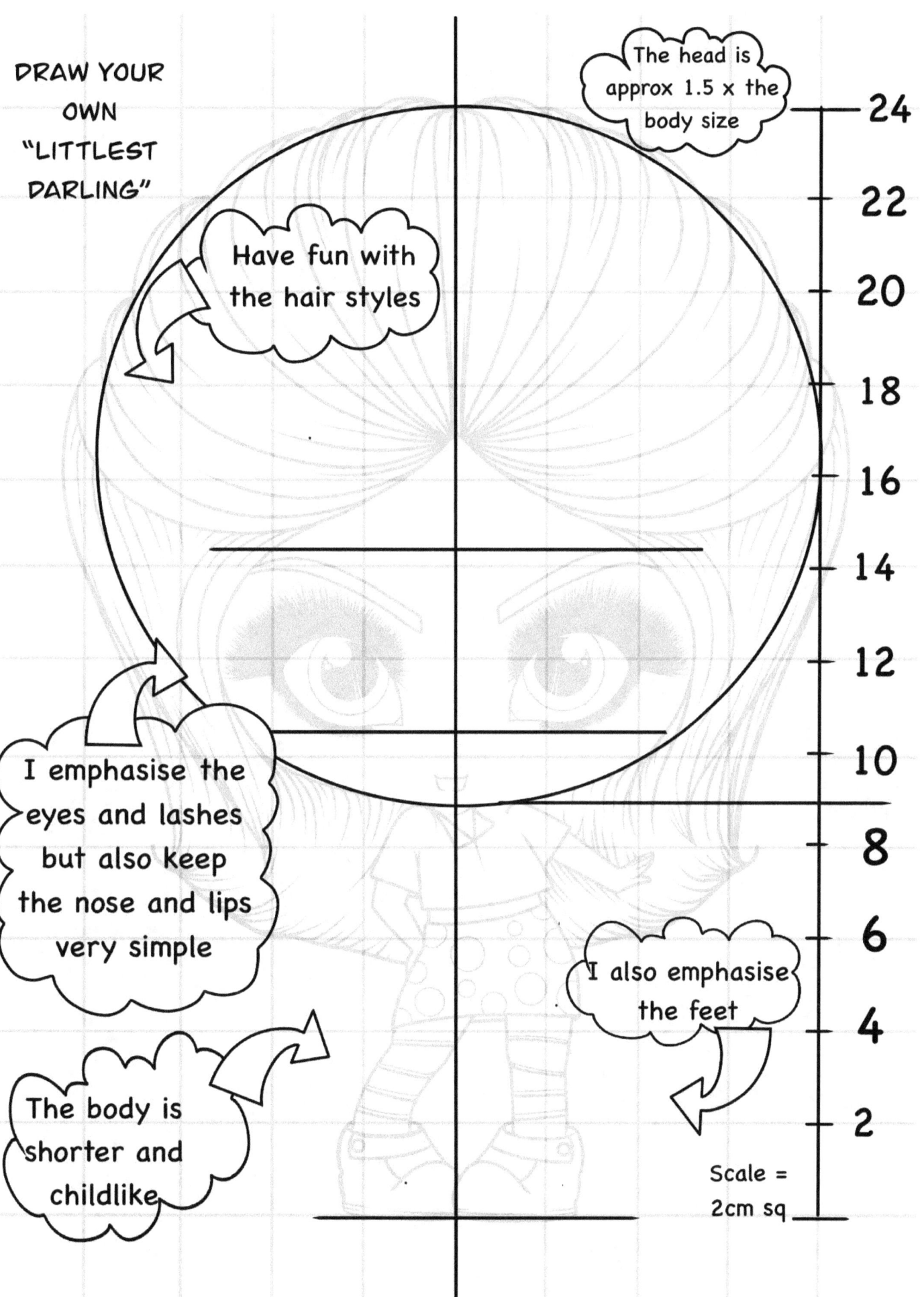

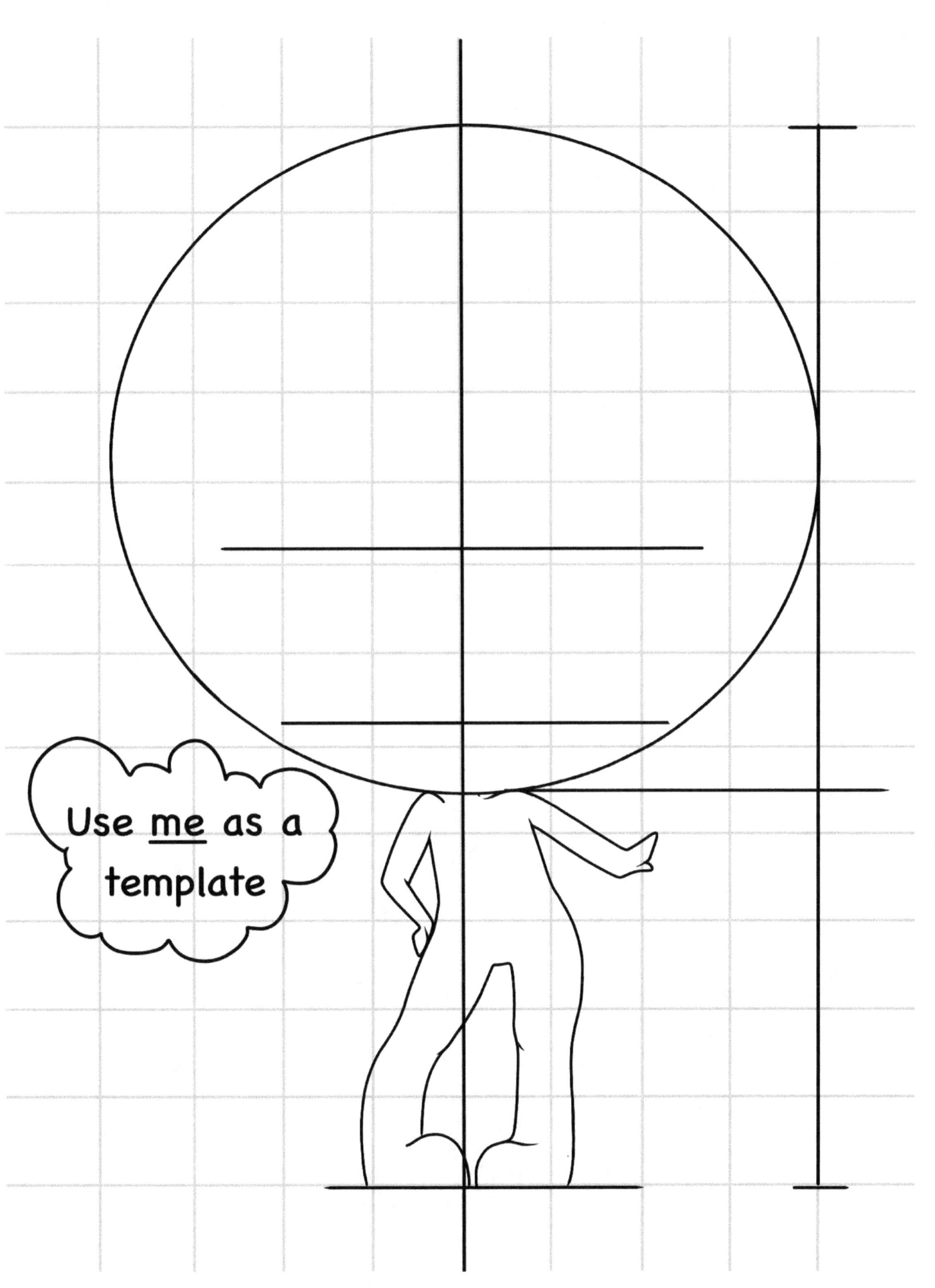

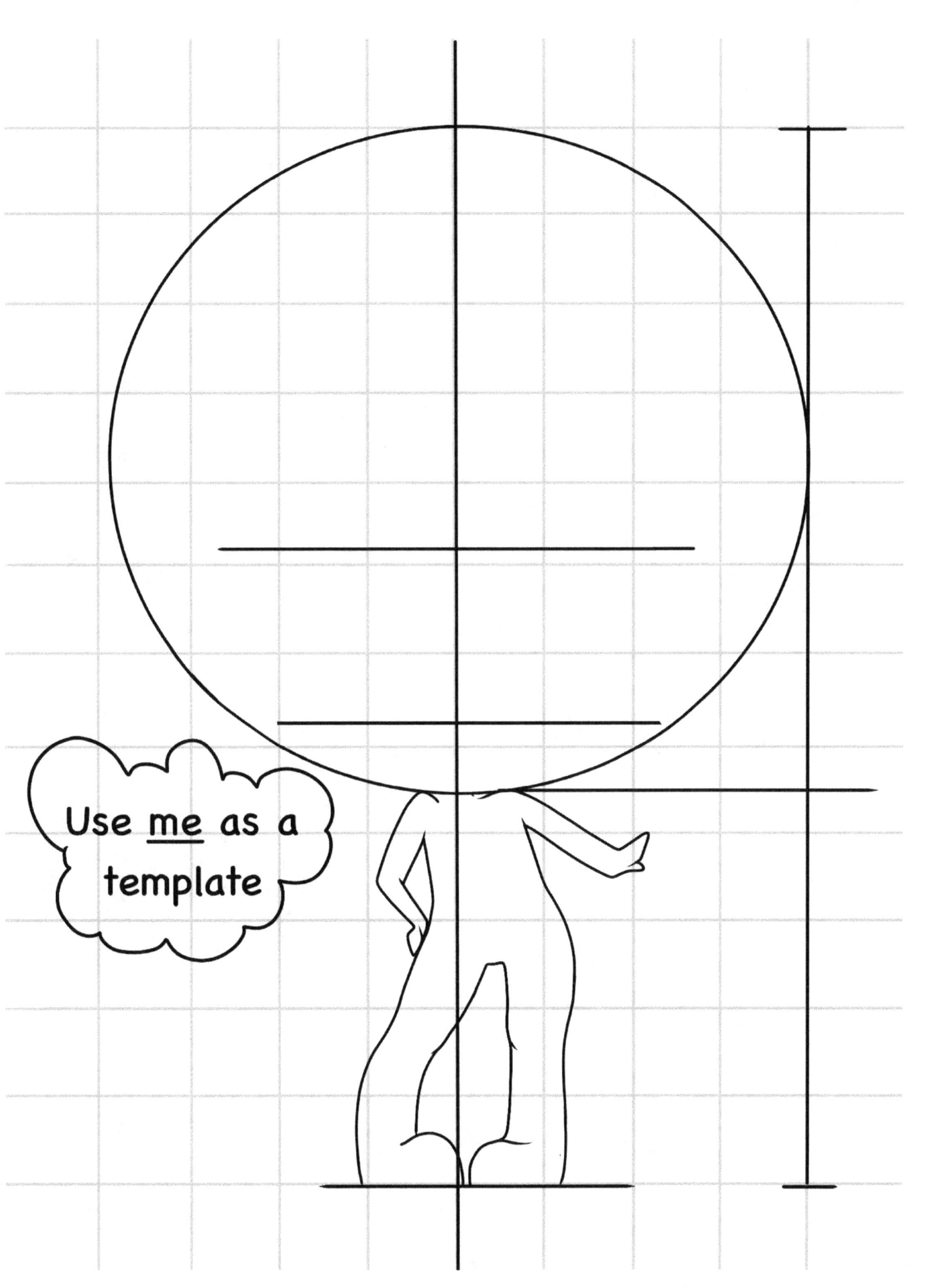

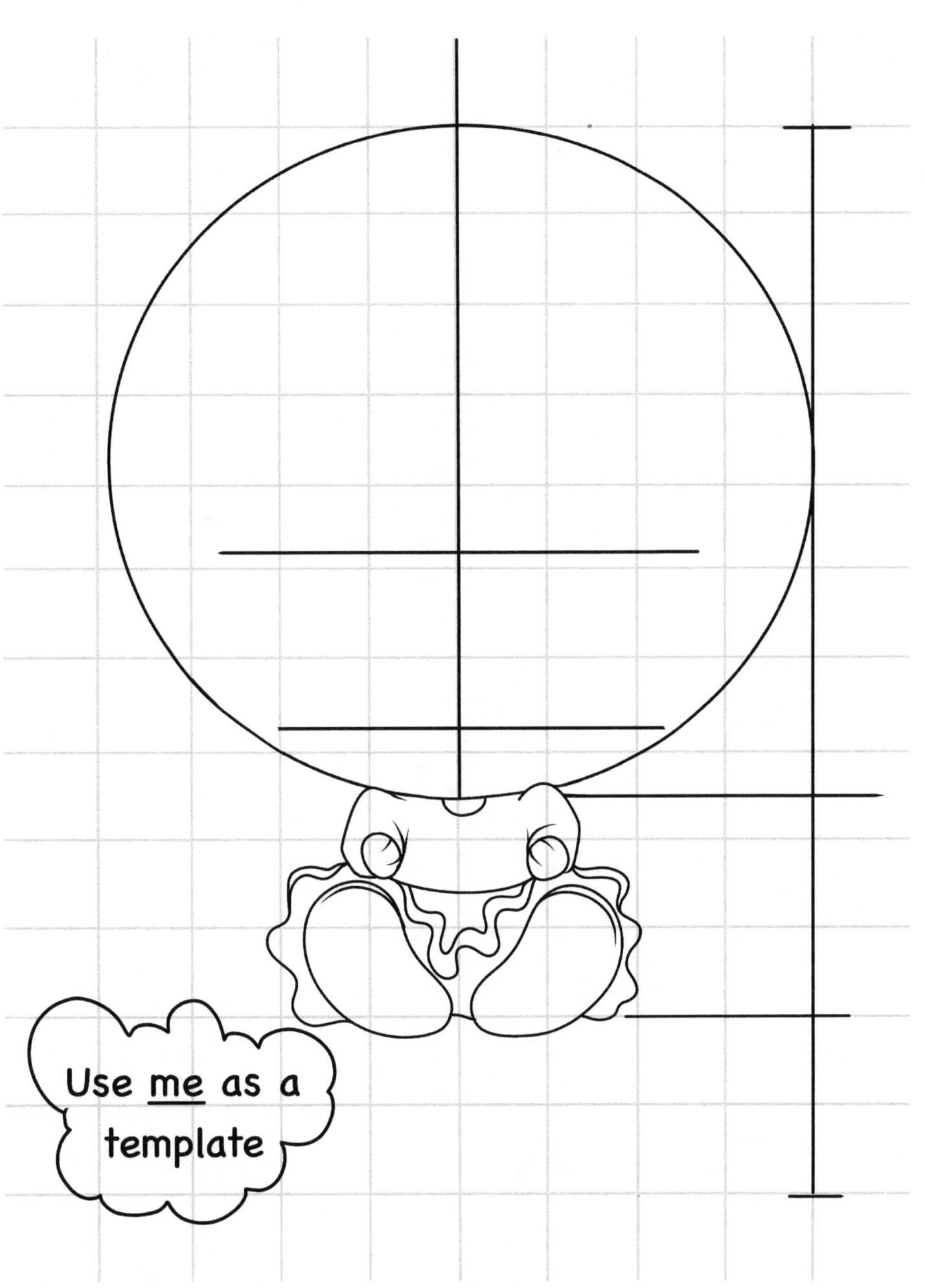

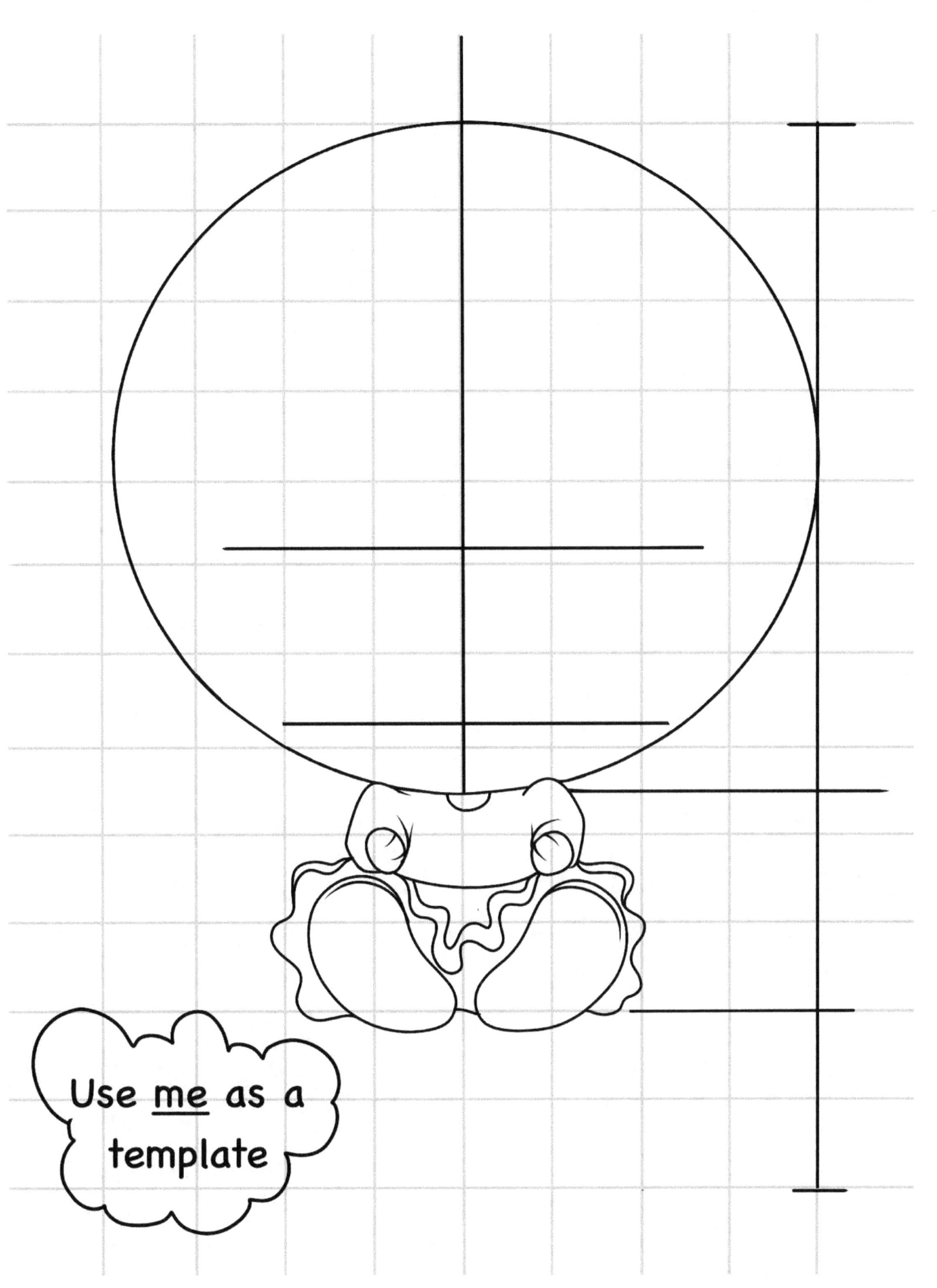

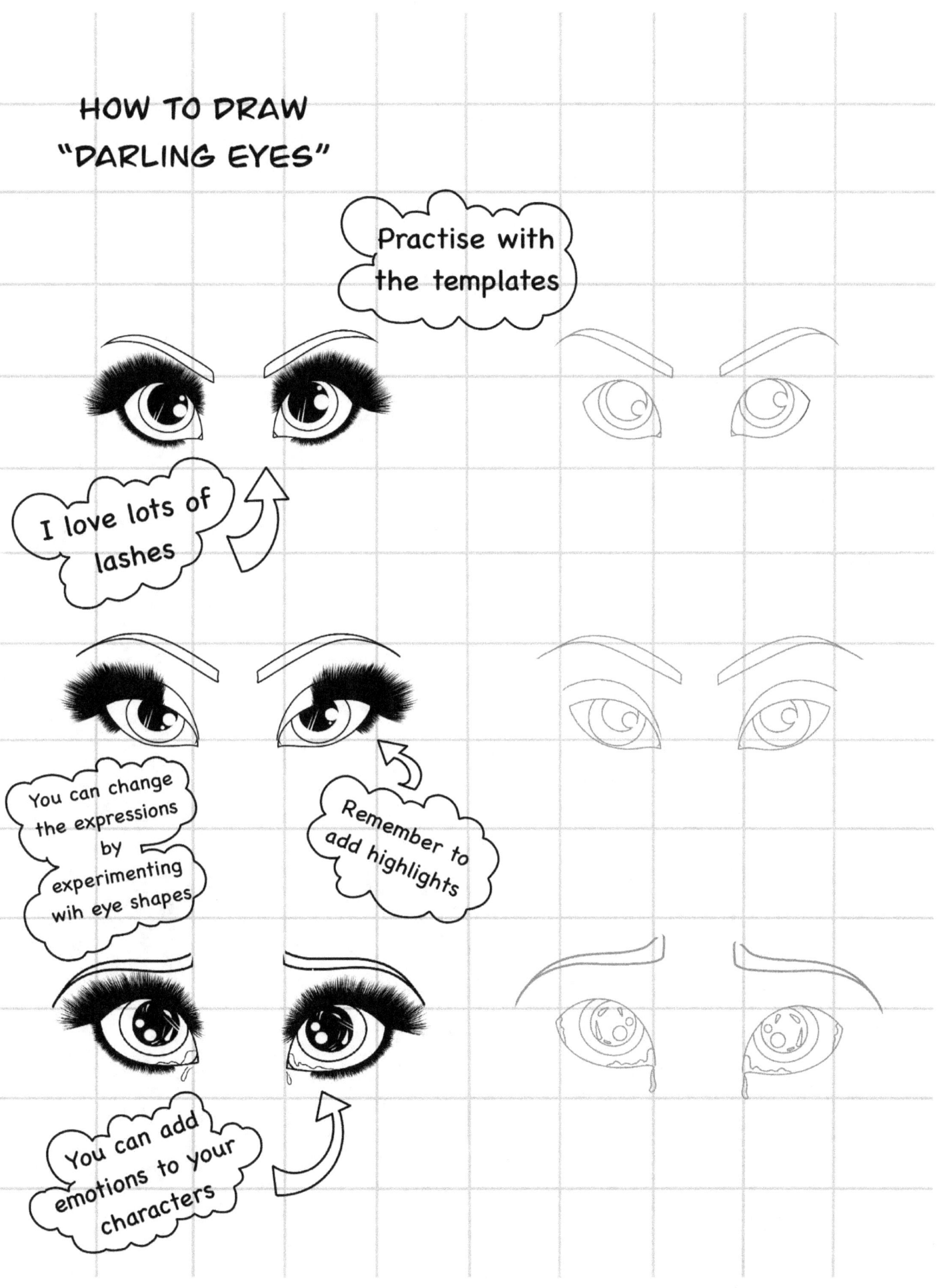

HOW TO DRAW "DARLING EYES"

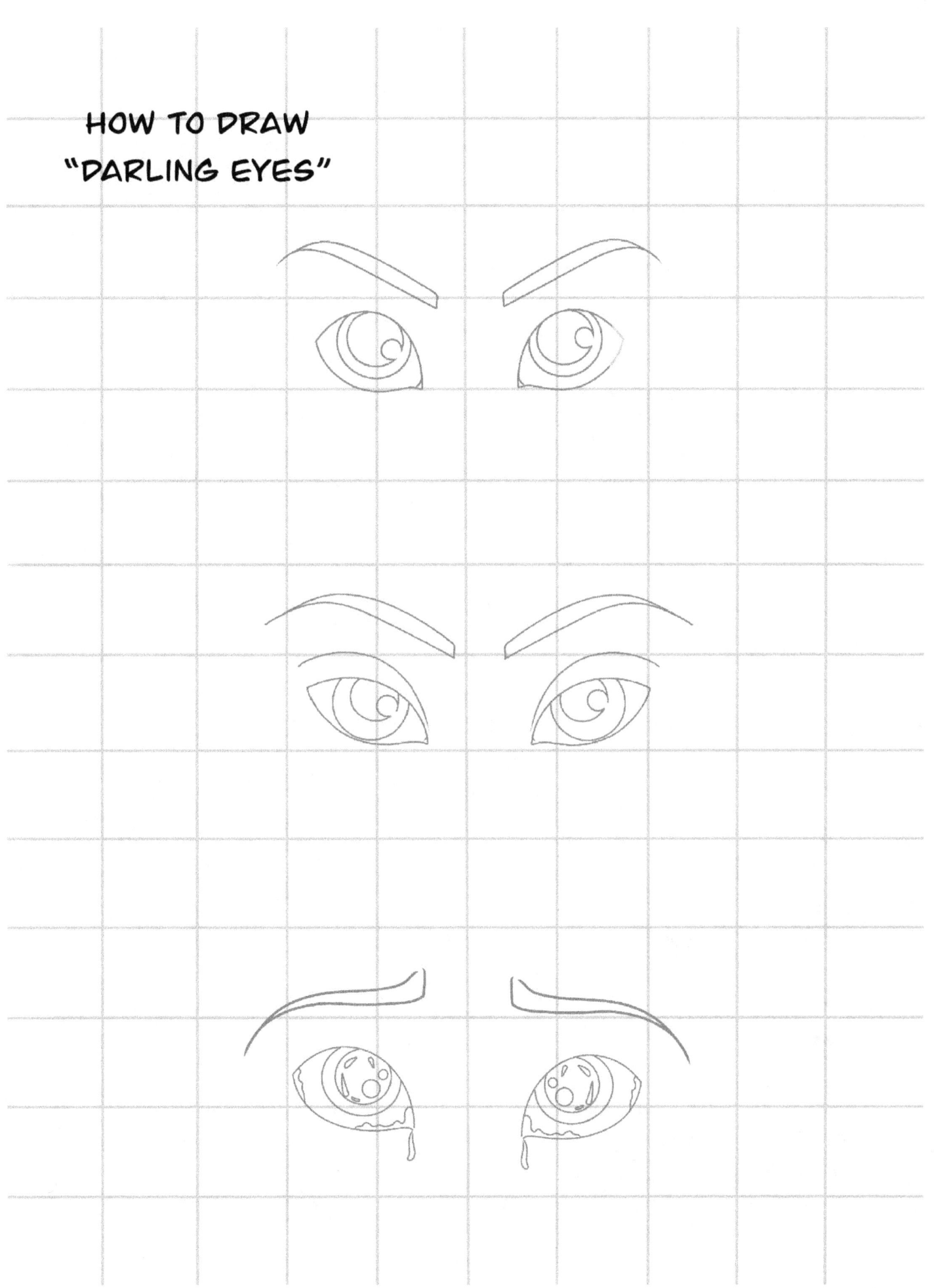

HOW TO DRAW "DARLING EYES"

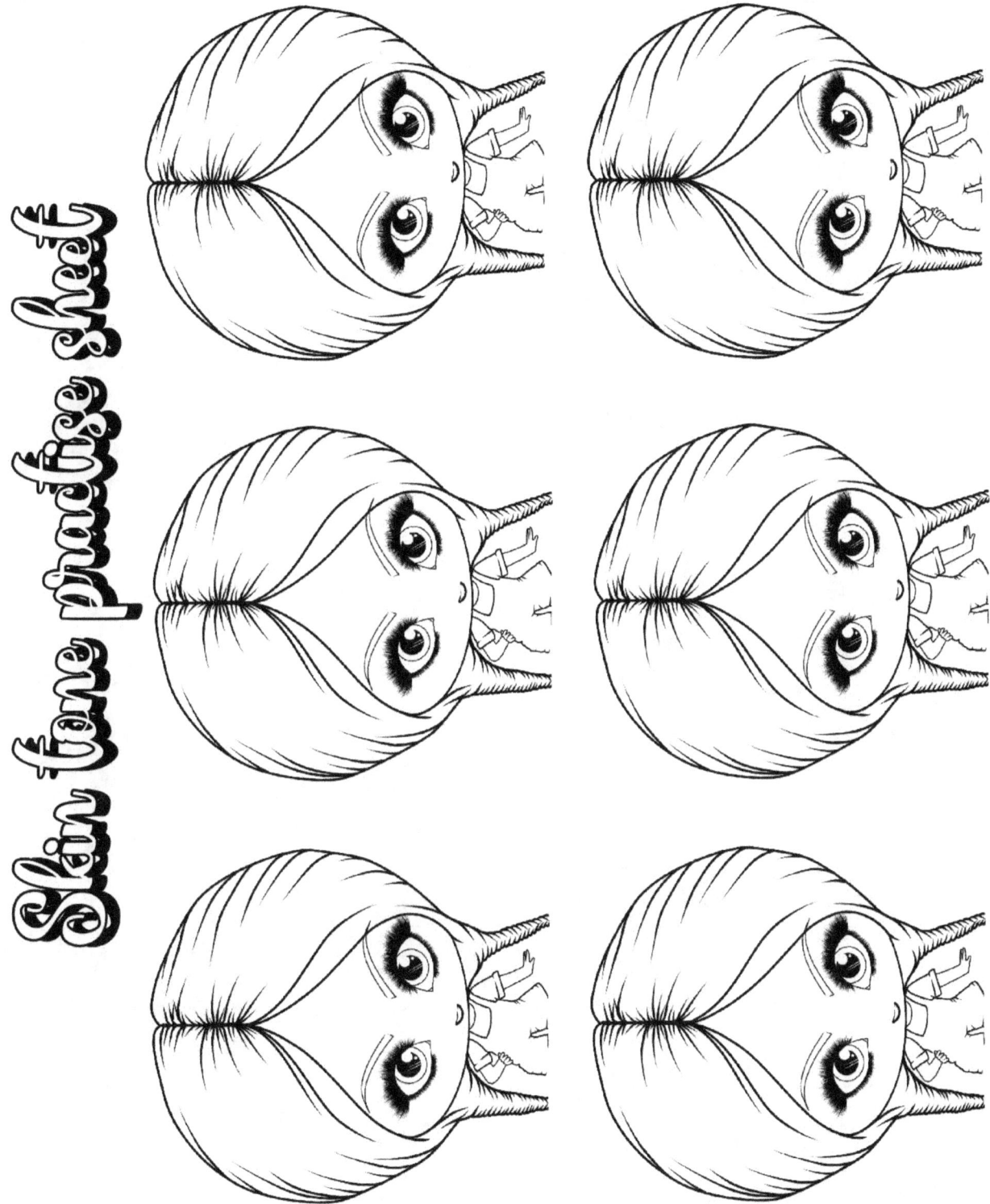

Colour Swatch Index

Thankyou for your purchase Of
The Littlest Darlings

Please Enjoy the following
bonus pages from my books
The Little Darlings and Storybook Darlings
Also keep a look out for my newest
books coming this year
The Little Darklings And Christmas Darlings

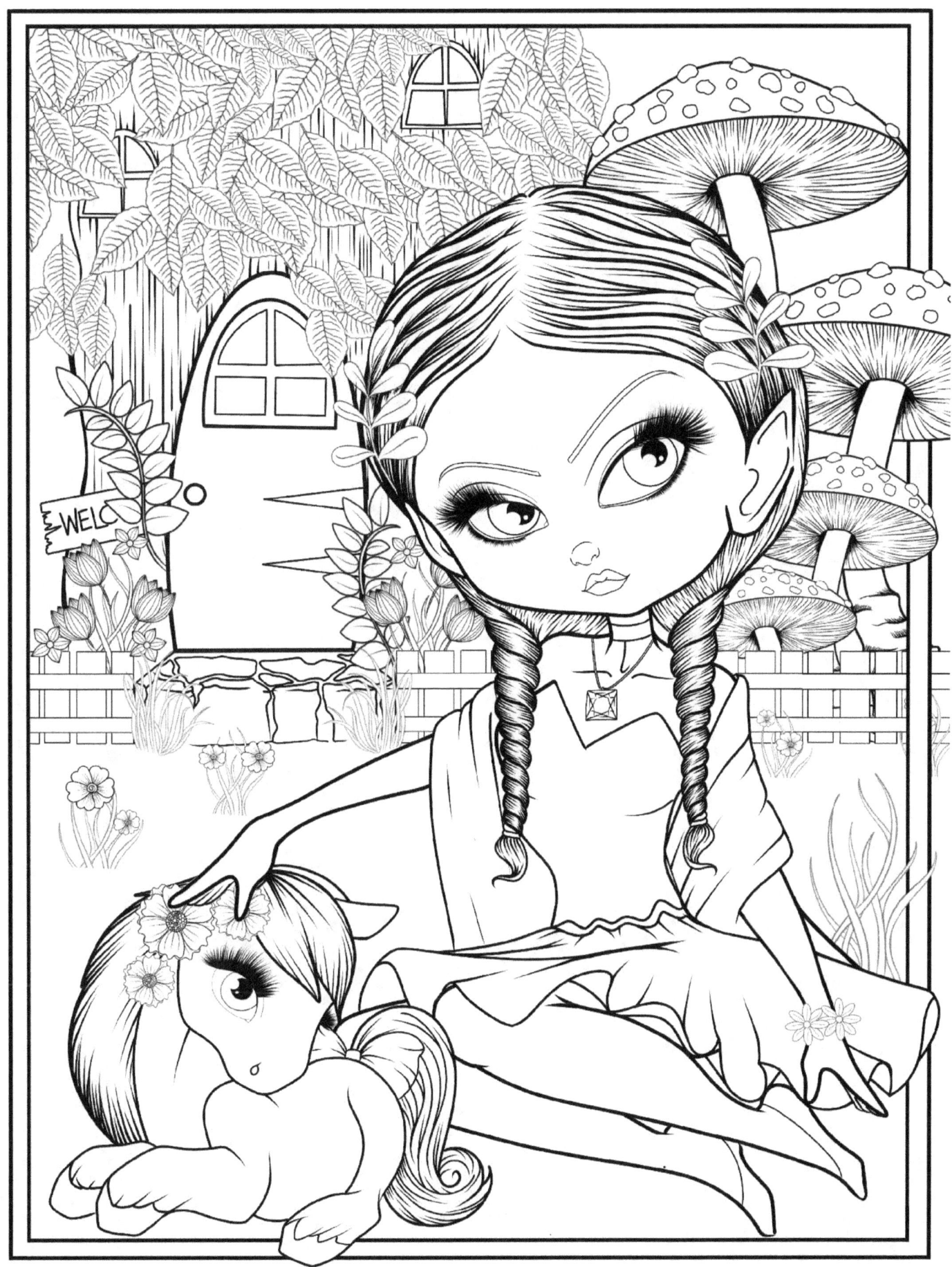
Little Darlings

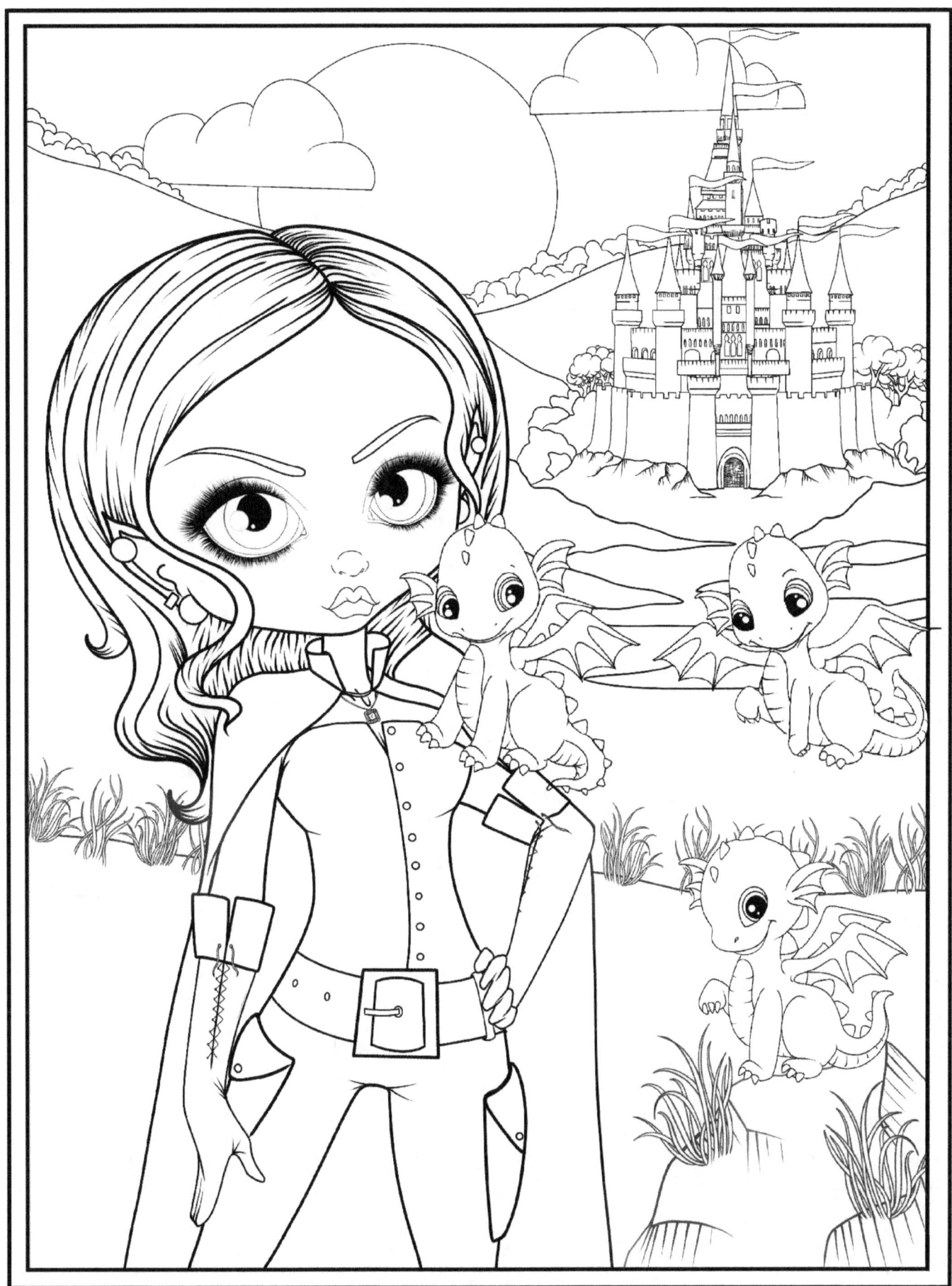

Little Darlings

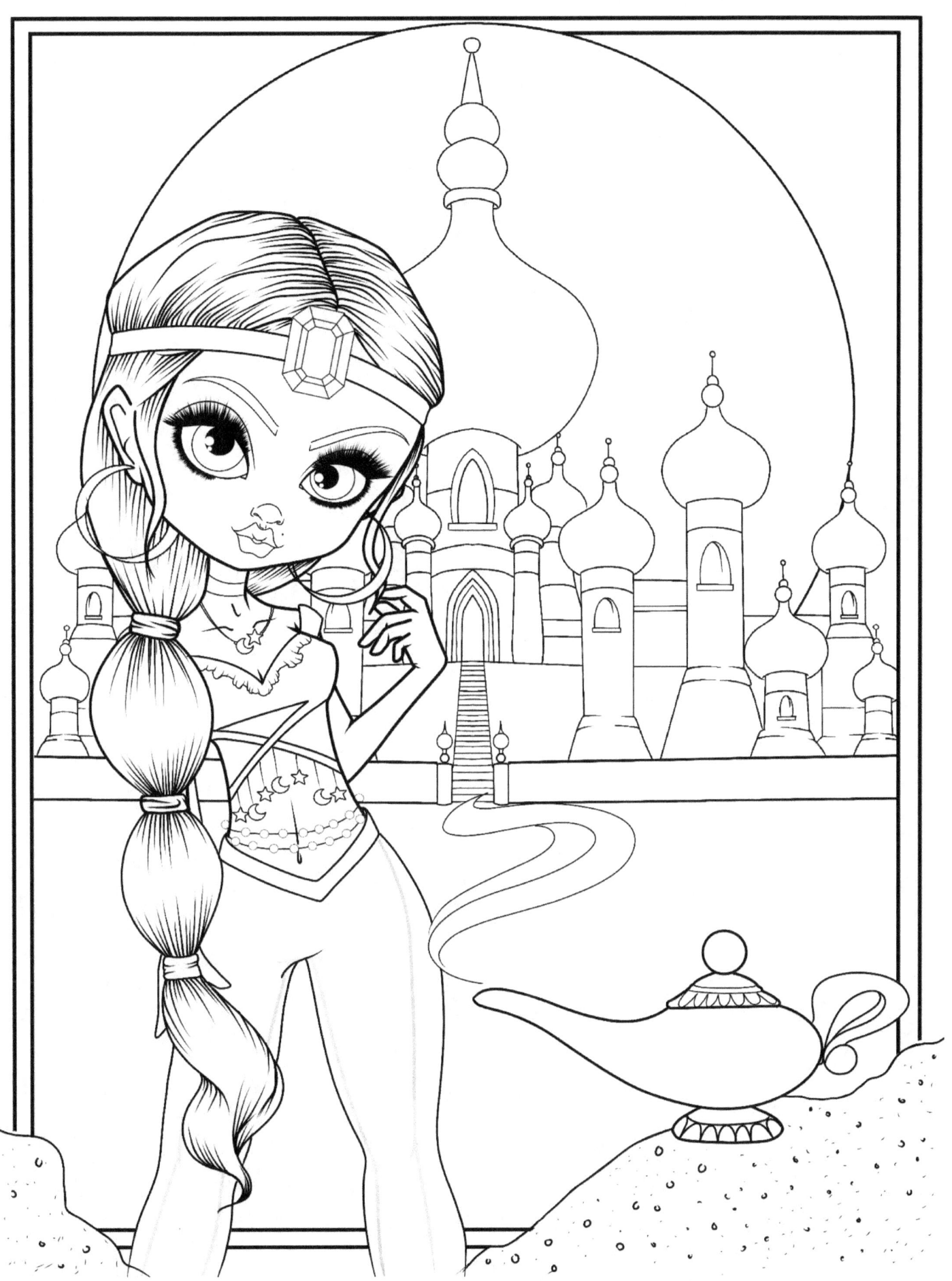

Storybook Darlings

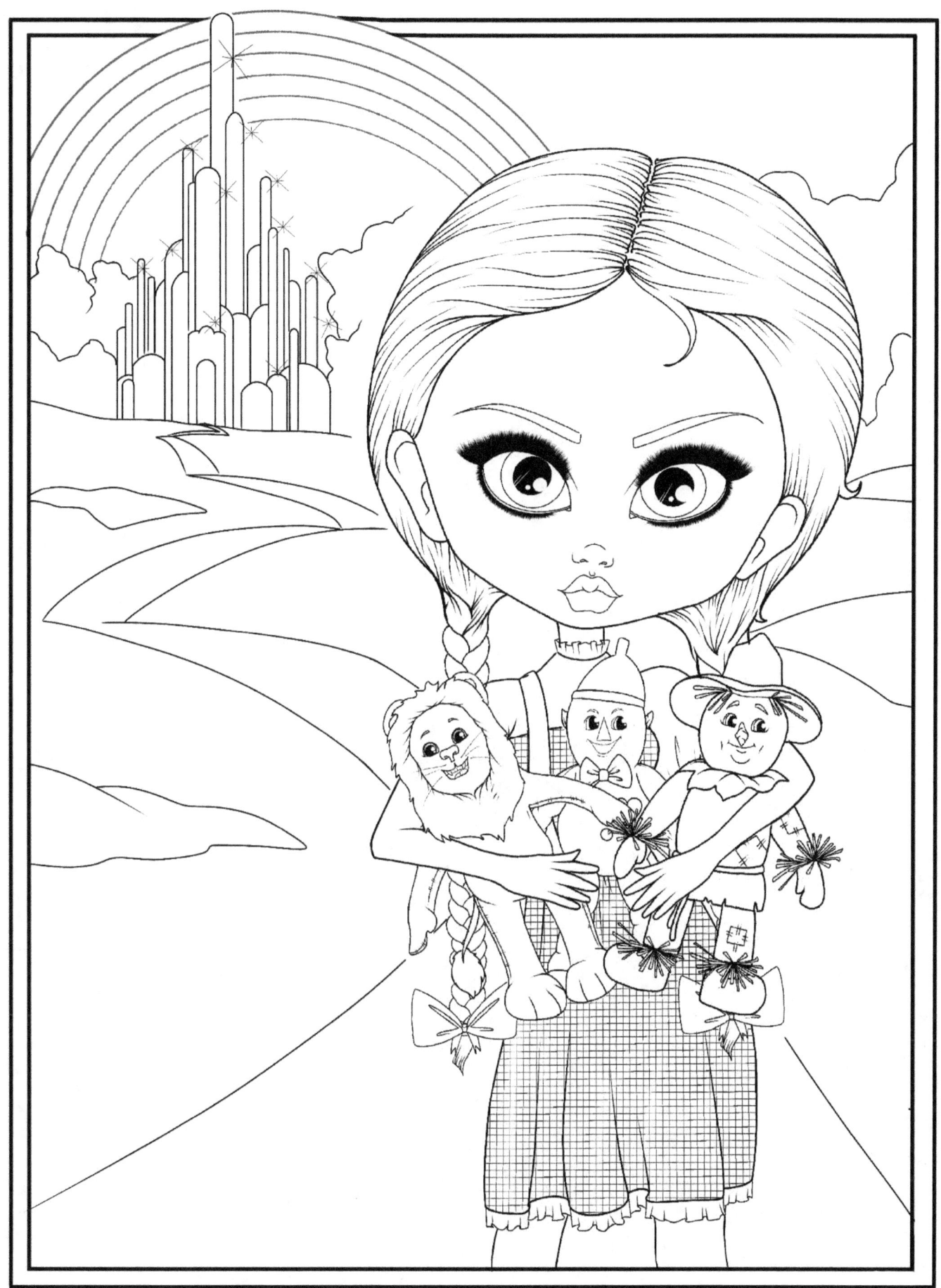

Storybook Darlings

Copyright 2019 Kelly Horton

ALL RIGHTS RESERVED

With the exception of those used in review's, the uncoloured or blank images herein, may not be reproduced, in whole or part by any means existing, other than for review.

The pages contained within are for personal use only. You may not distribute to or share uncoloured blank pages with any other colourists, in colouring groups, colouring group parties, via Email or message etc. to any other person, group, people or entity, and you may not upload blank or uncoloured pages to the internet without prior written permission of the artist and author Kelly Horton / The colouring Collective publications.

For any further details, including information on other books or colouring pages contact:

Kellyartistthorton@yahoo.com

For more colouring pages:

www.etsy.com/uk/Colourcollectiveshop

Join the Facebook Community at

The Colouring Collective

www.ingramcontent.com/pod-product-compliance
Lightning Source LLC
Chambersburg PA
CBHW080942170526
45158CB00008B/2349